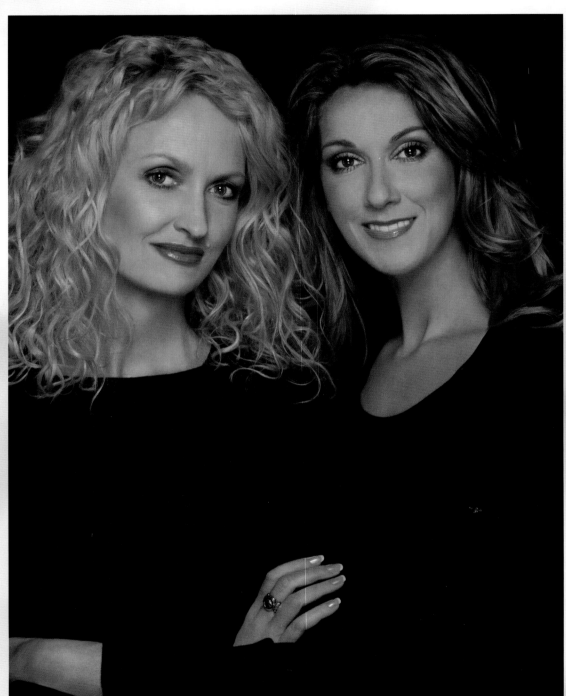

Miracle

a celebration of new life

"Each new life is truly a miracle. I photograph babies to portray and promote the absolute promise of a newborn, the powerful potentia of a child to be an extraordinary human being. It has been both a pleasure and a privilege to create the *Miracle* project with Celine, whose vocal artistry completely captures our shared love for children."

Anne

"I've always been a huge fan of Anne's. Long before I became a mother, I admired and appreciated the beautiful way she photographs babies. It has been wonderful working with her on this very special project."

Celine

"*Miracle* comes straight from our hearts."

the first time ever I saw your face

the first time ever I saw your face
I thought the sun rose in your eyes
and the moon and the stars were the gifts you gave
to the dark and the endless skies my love

the first time ever I kissed your mouth
I felt the earth move through my hand
like the trembling heart of a captive bird
that was there at my command my love

the first time ever I lay with you
and felt your heart so close to mine
the first time ever I saw your face
your face, your face, your face

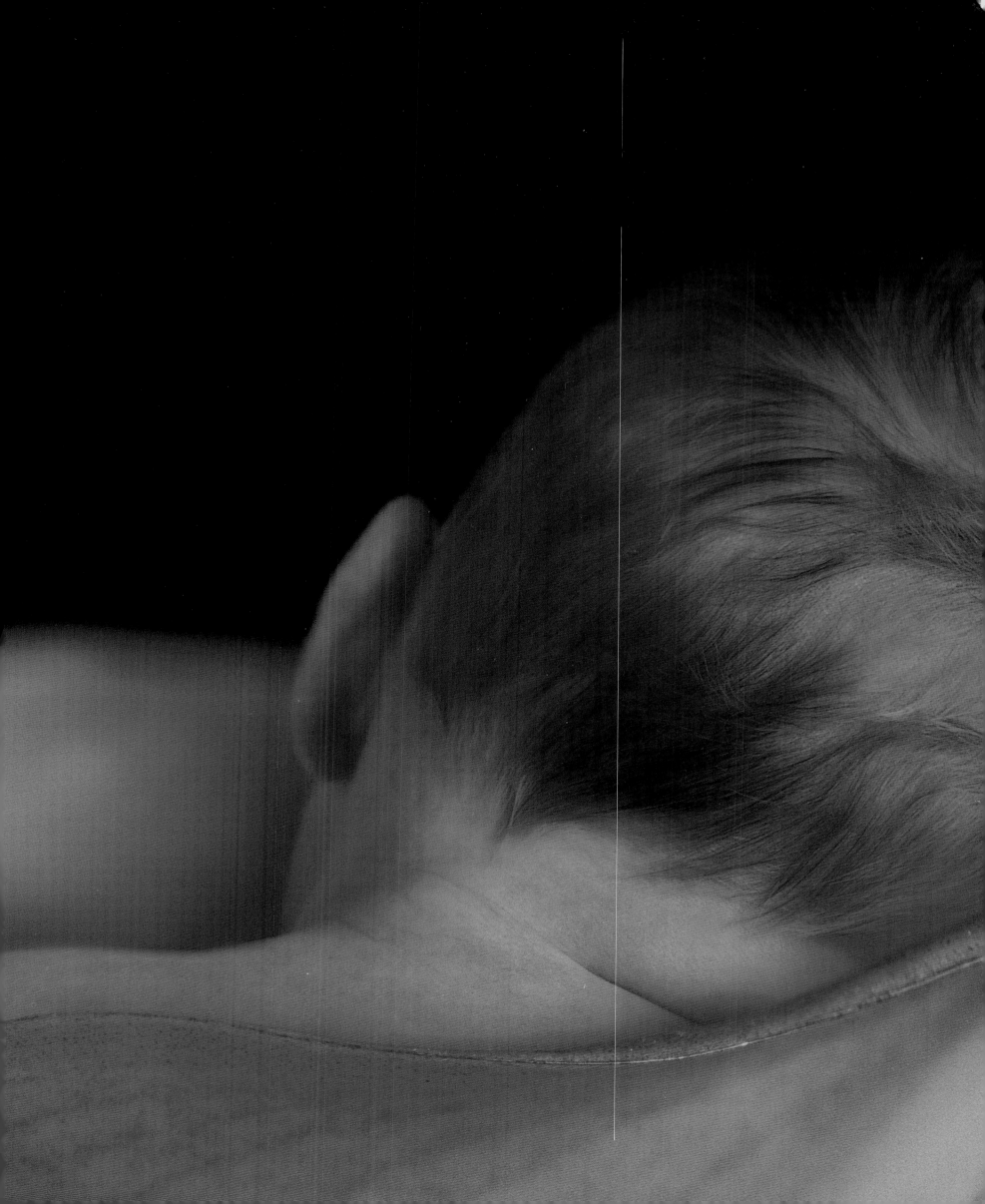

the first time ever I saw your face

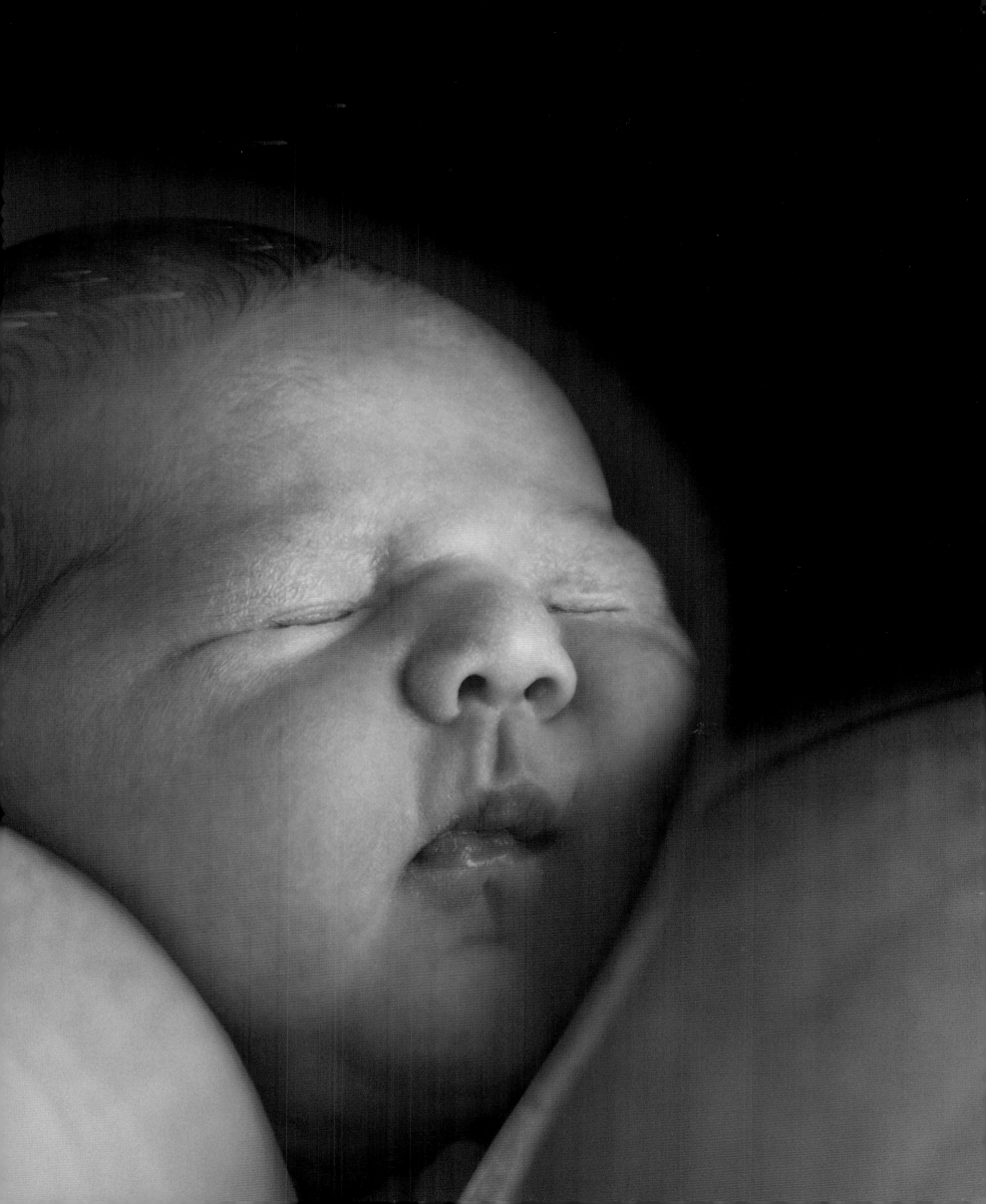

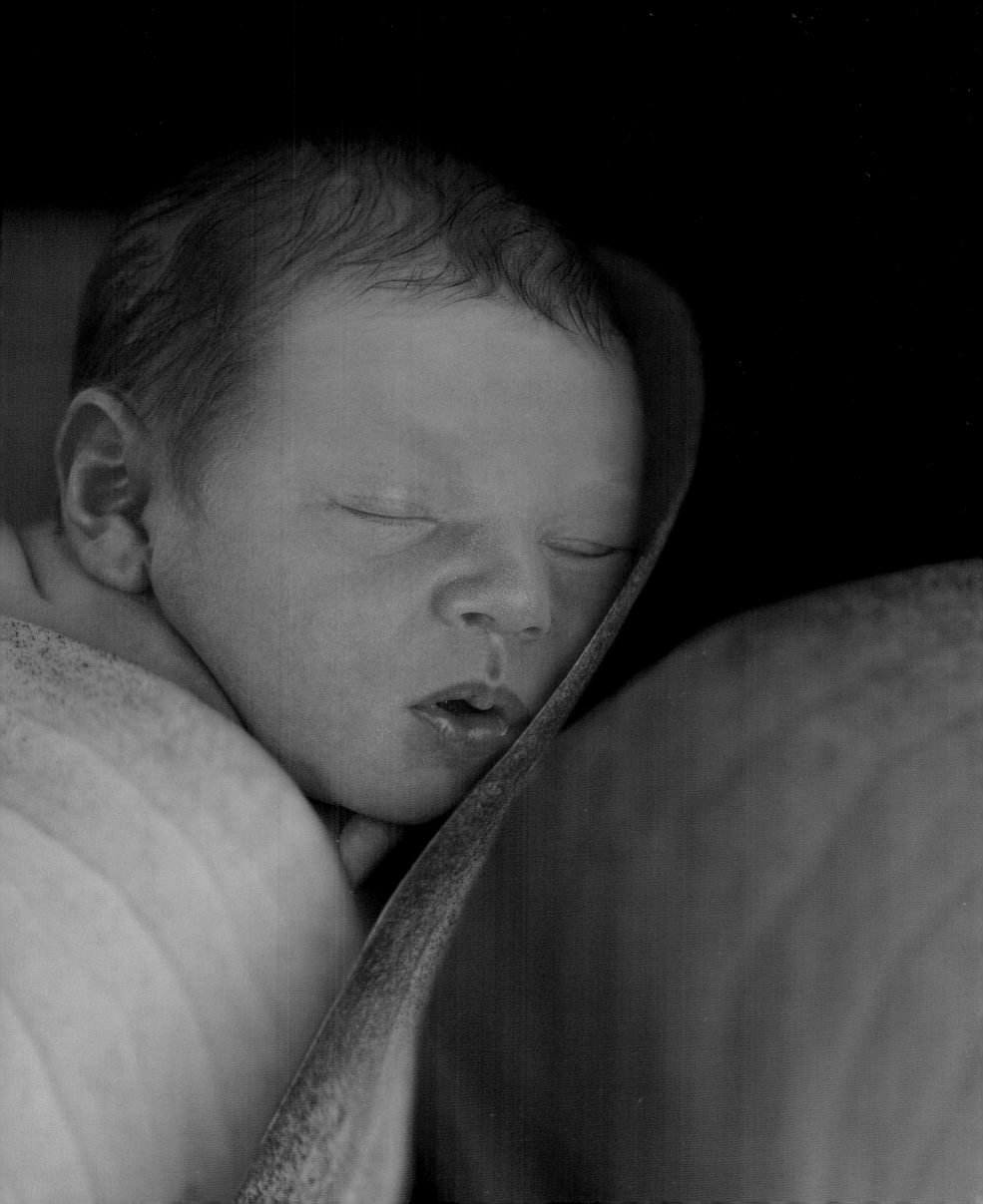

the gifts

and the moon and the stars

were the gifts you gave

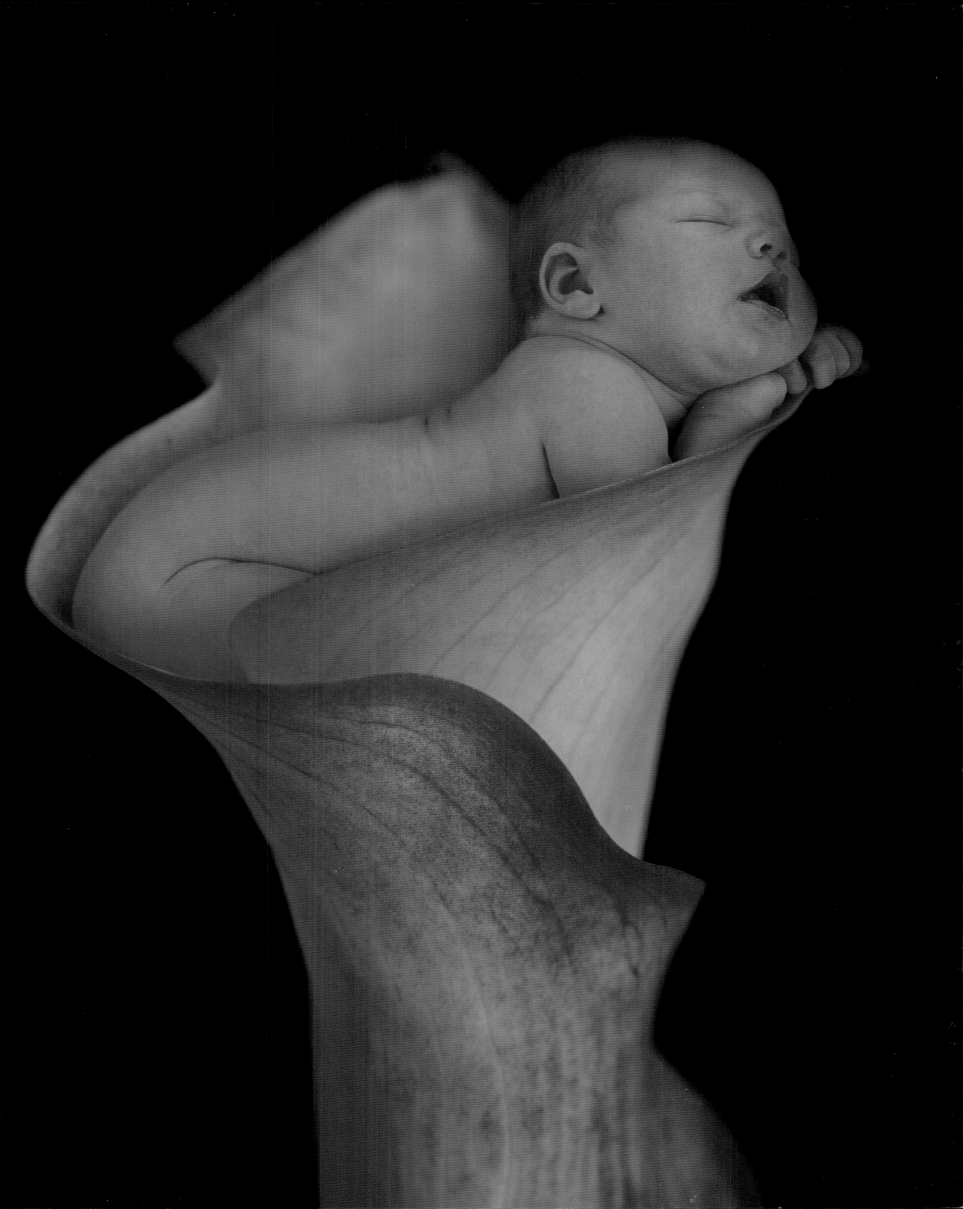

to the dark and the endless skies

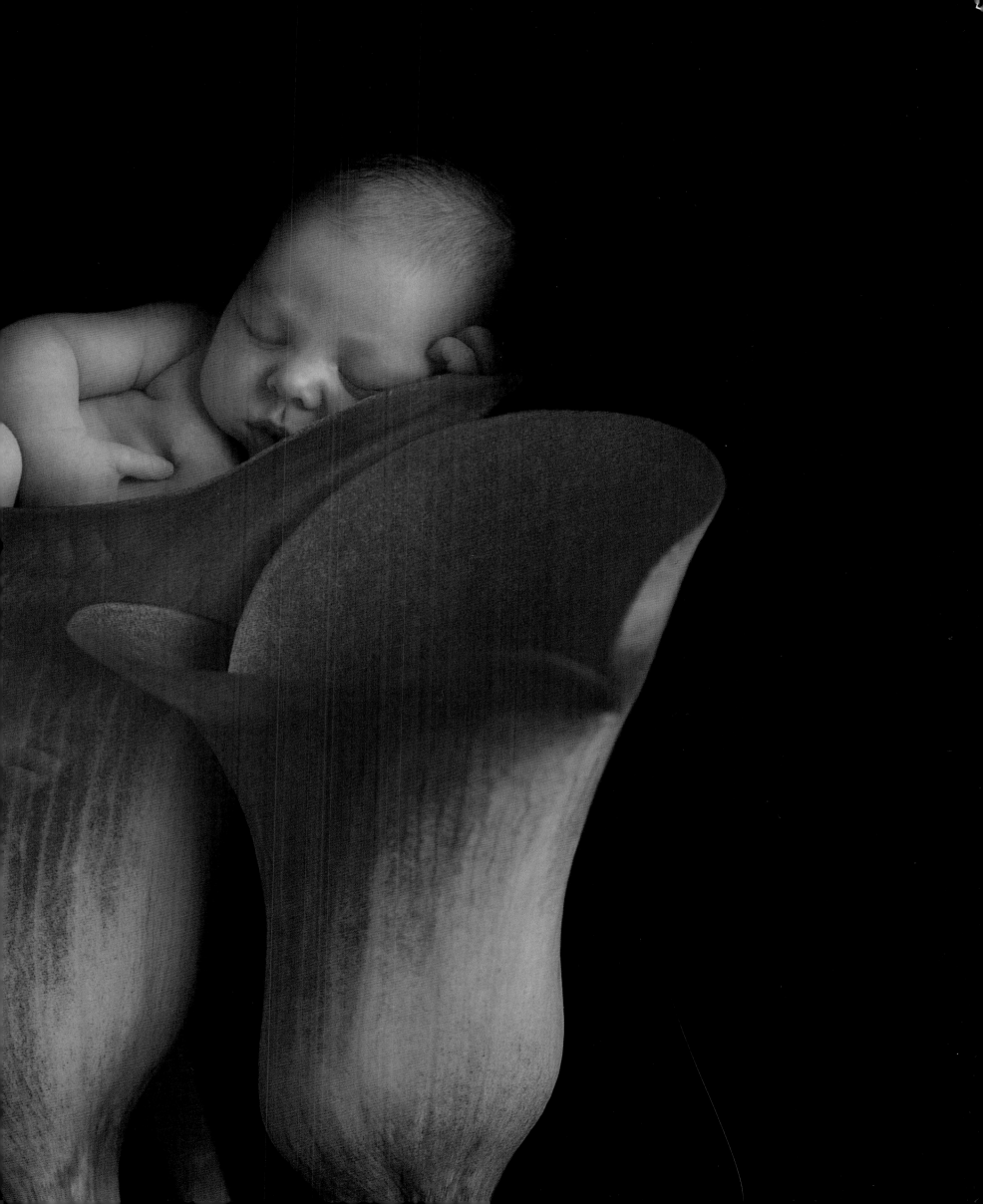

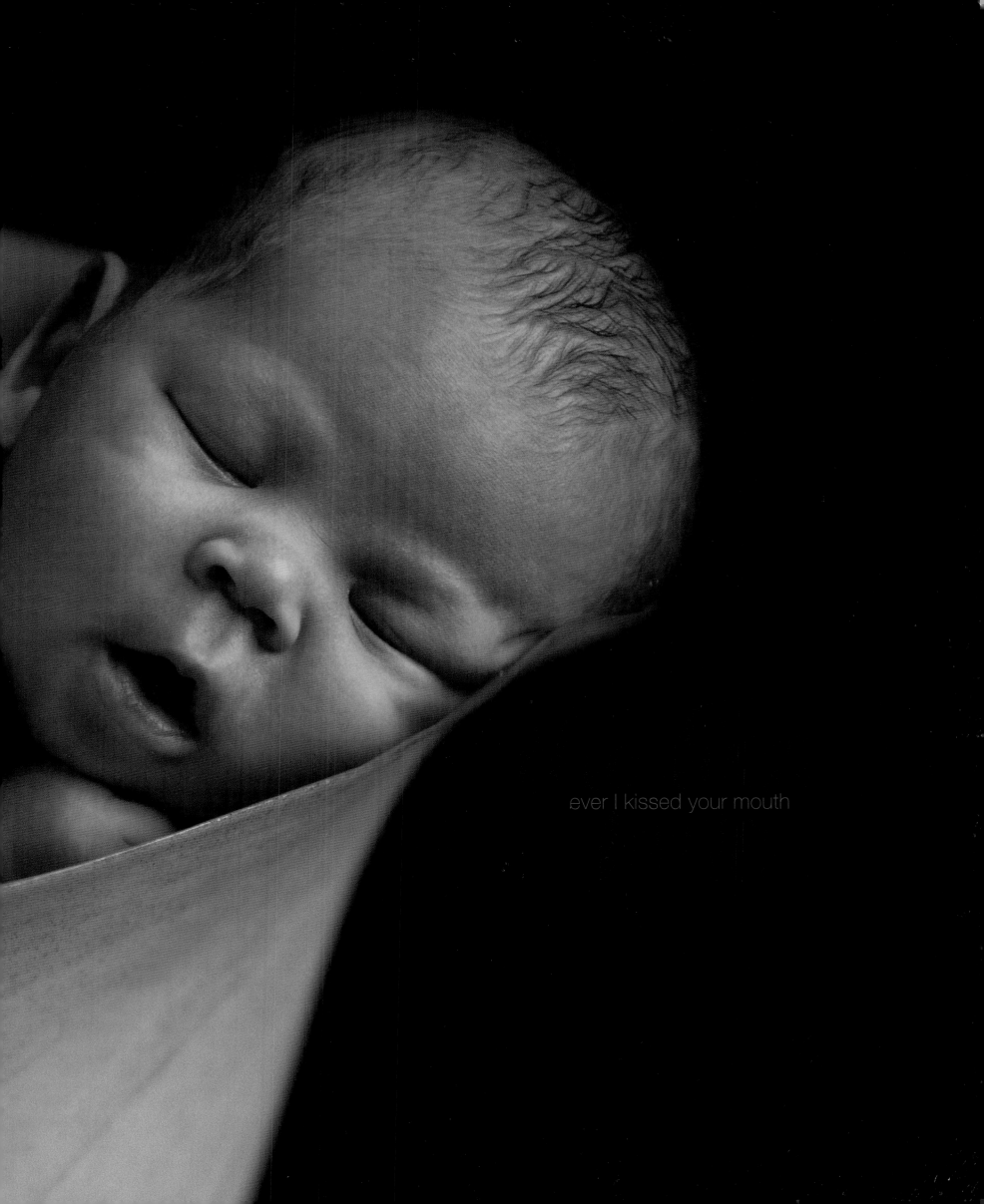

ever I kissed your mouth

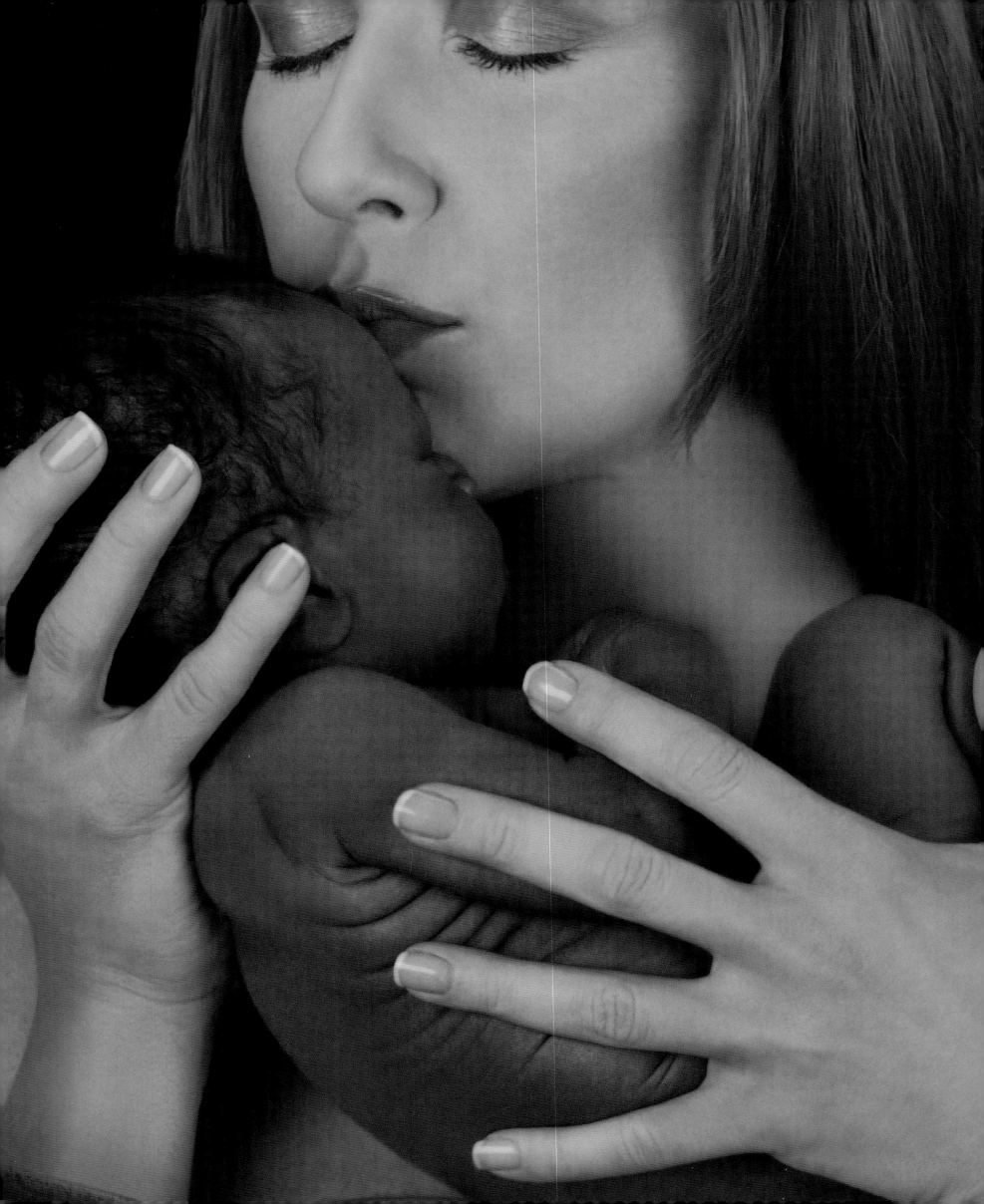

move through my hand

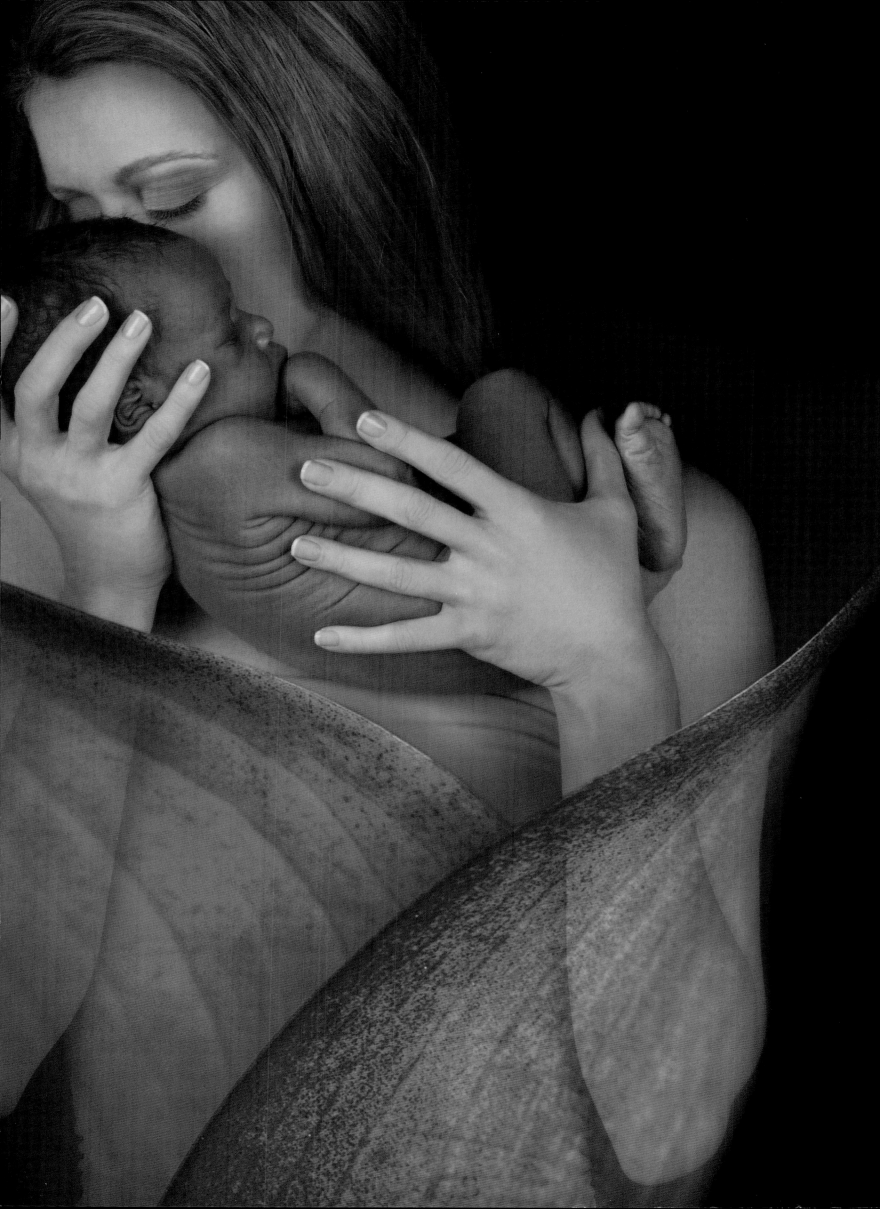

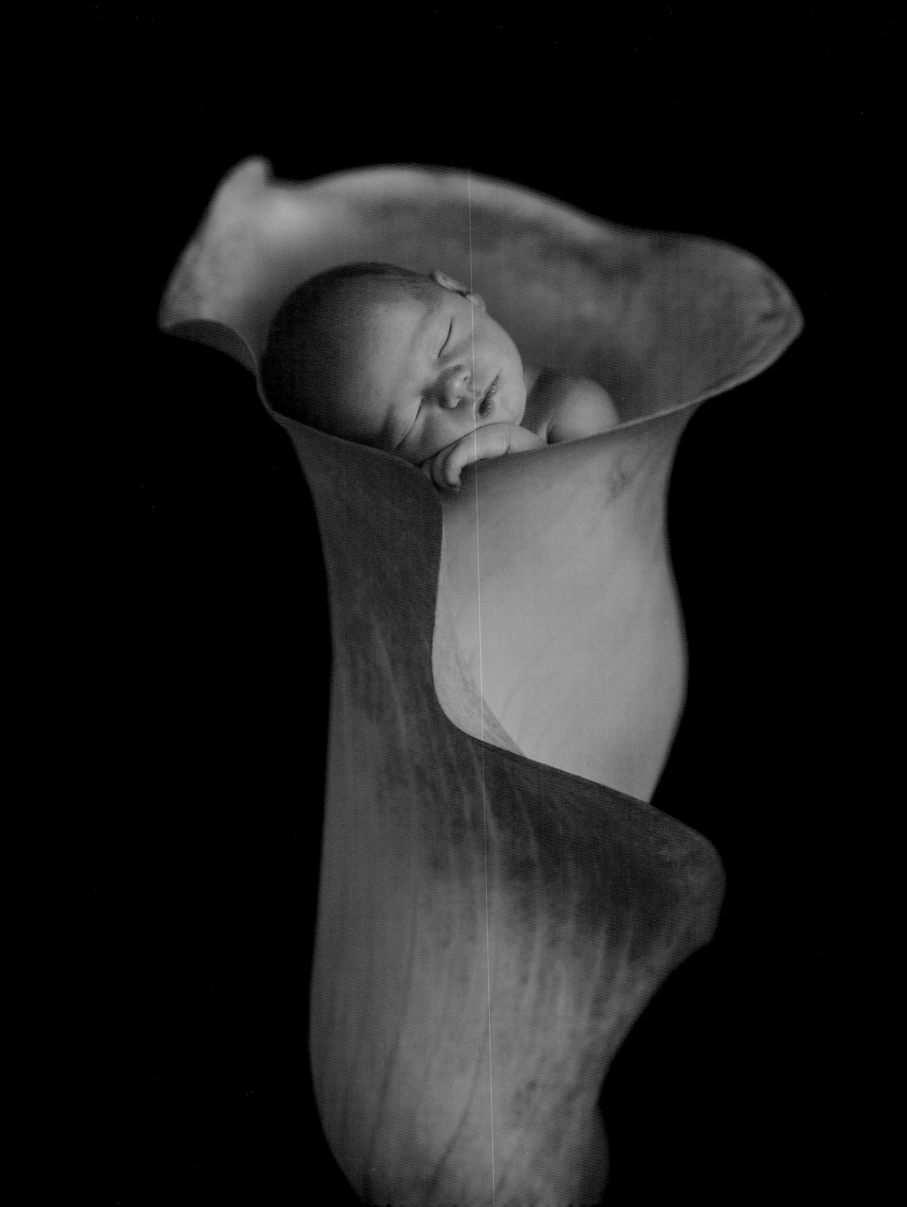

my love

ever I lay with you

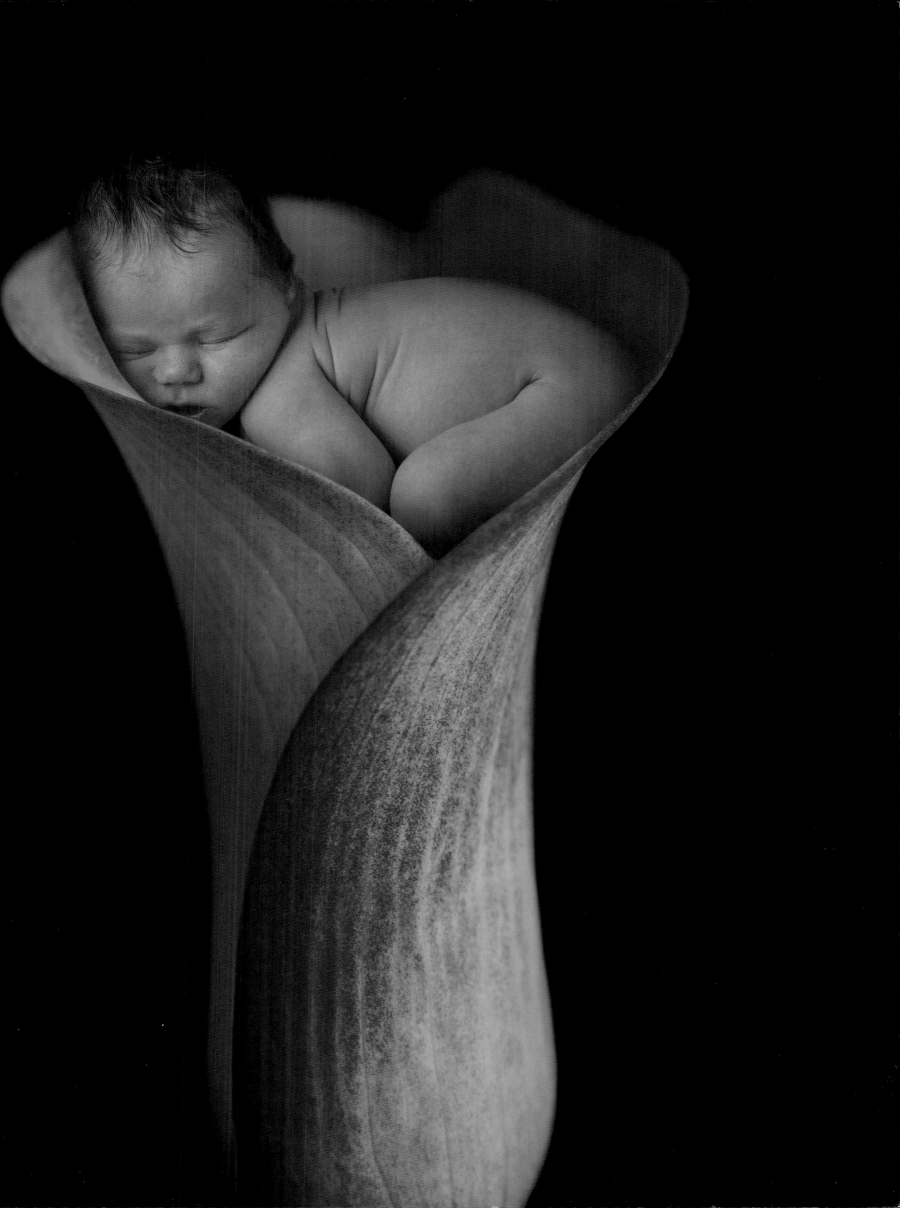

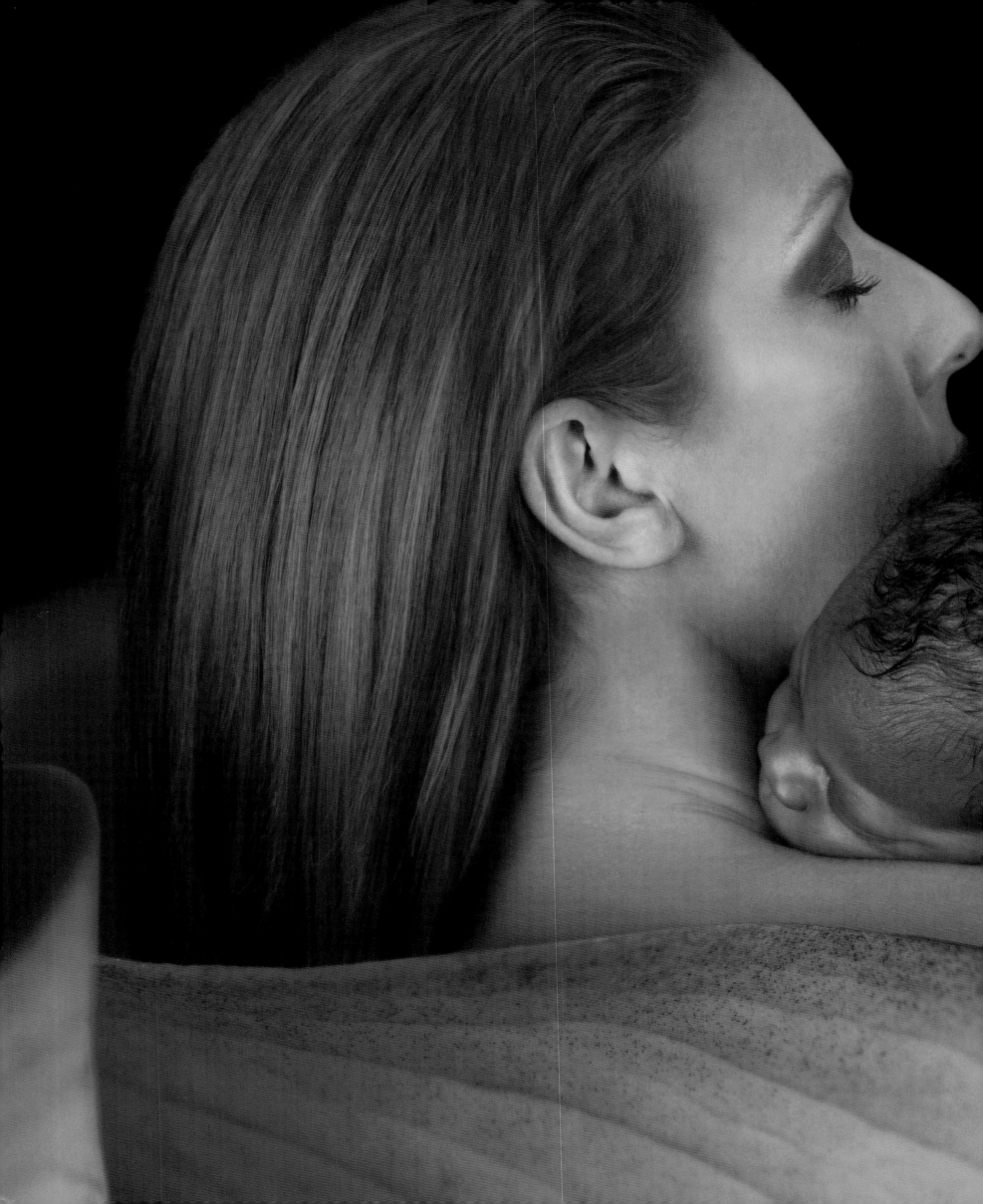

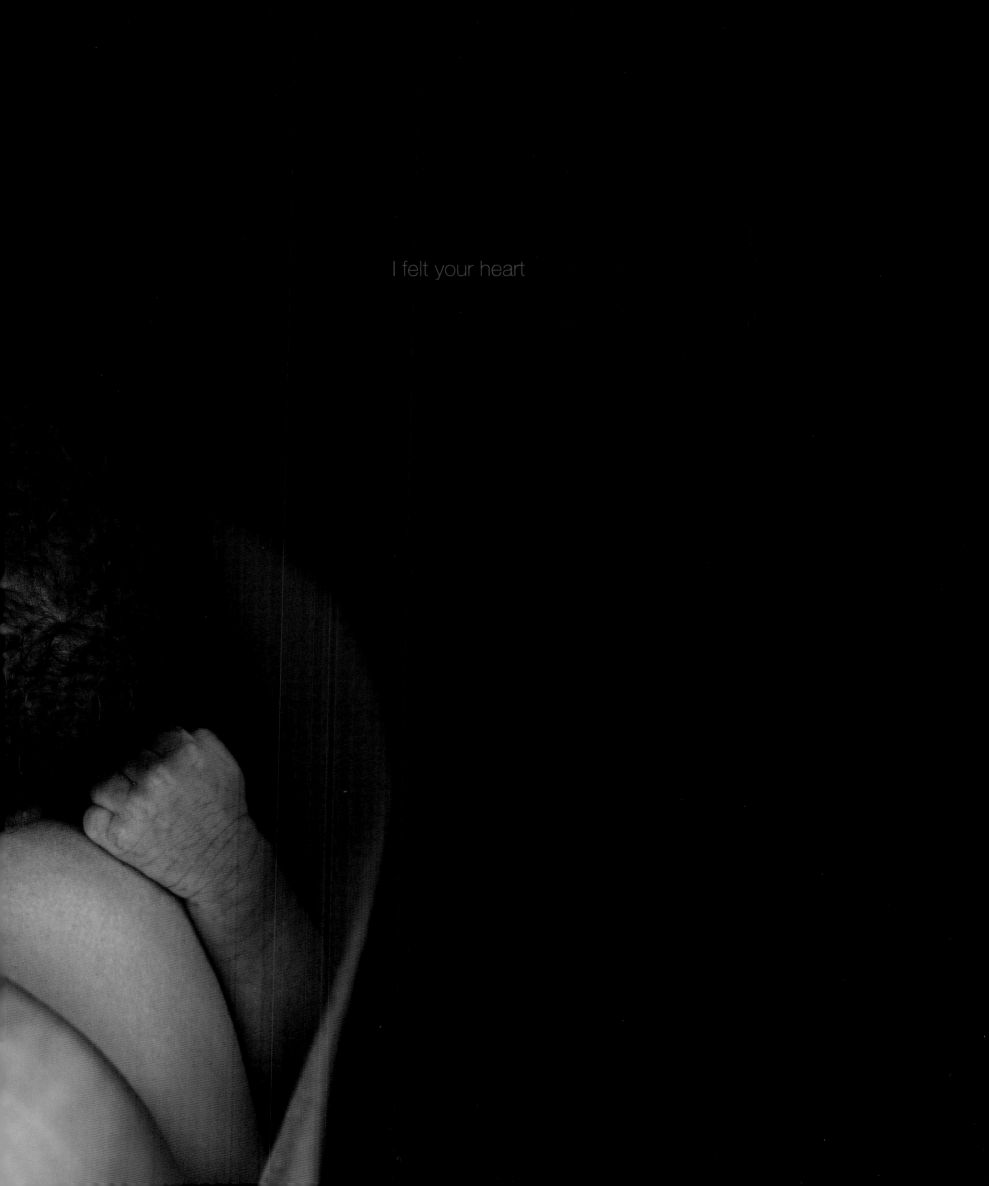

I felt your heart

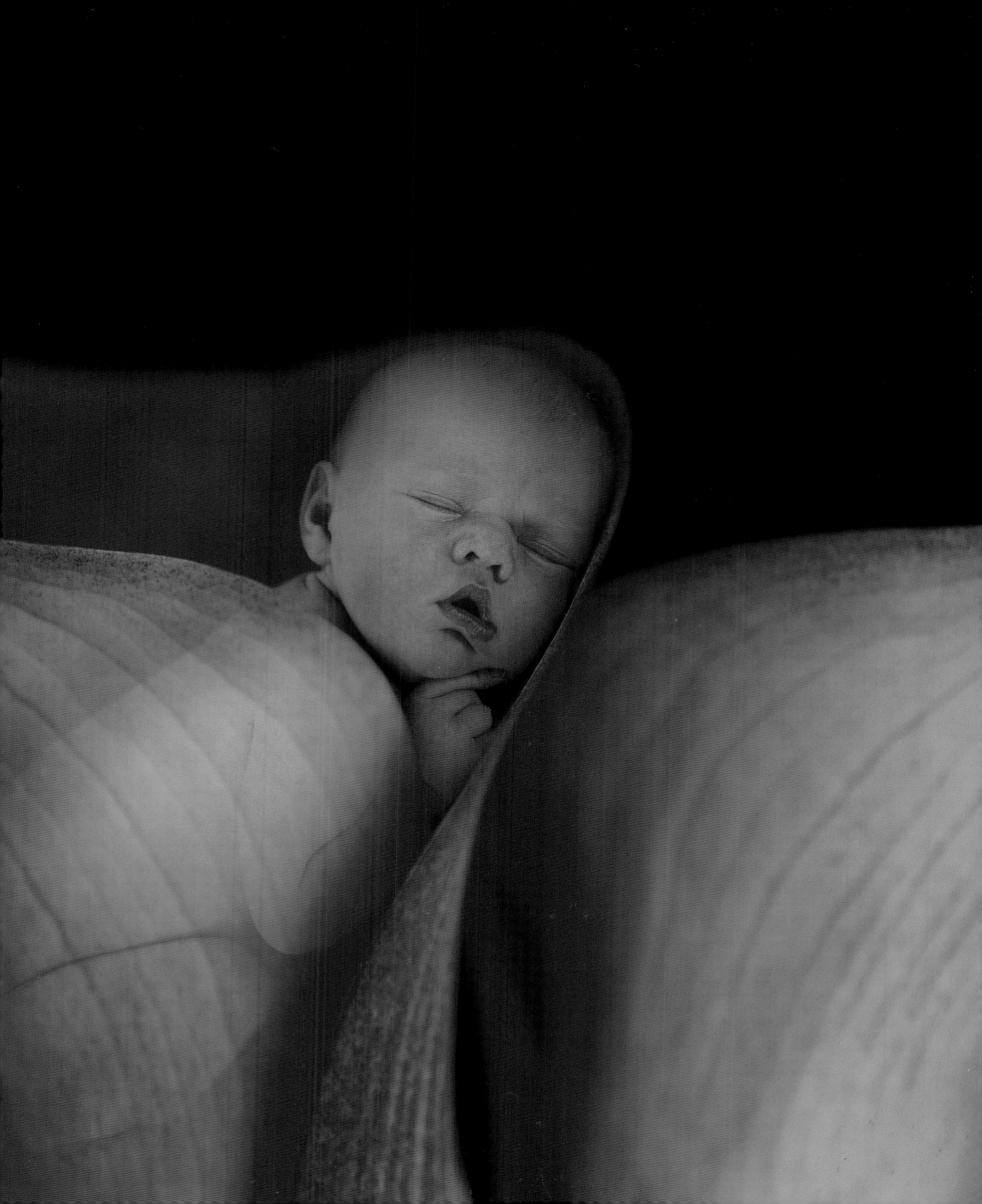

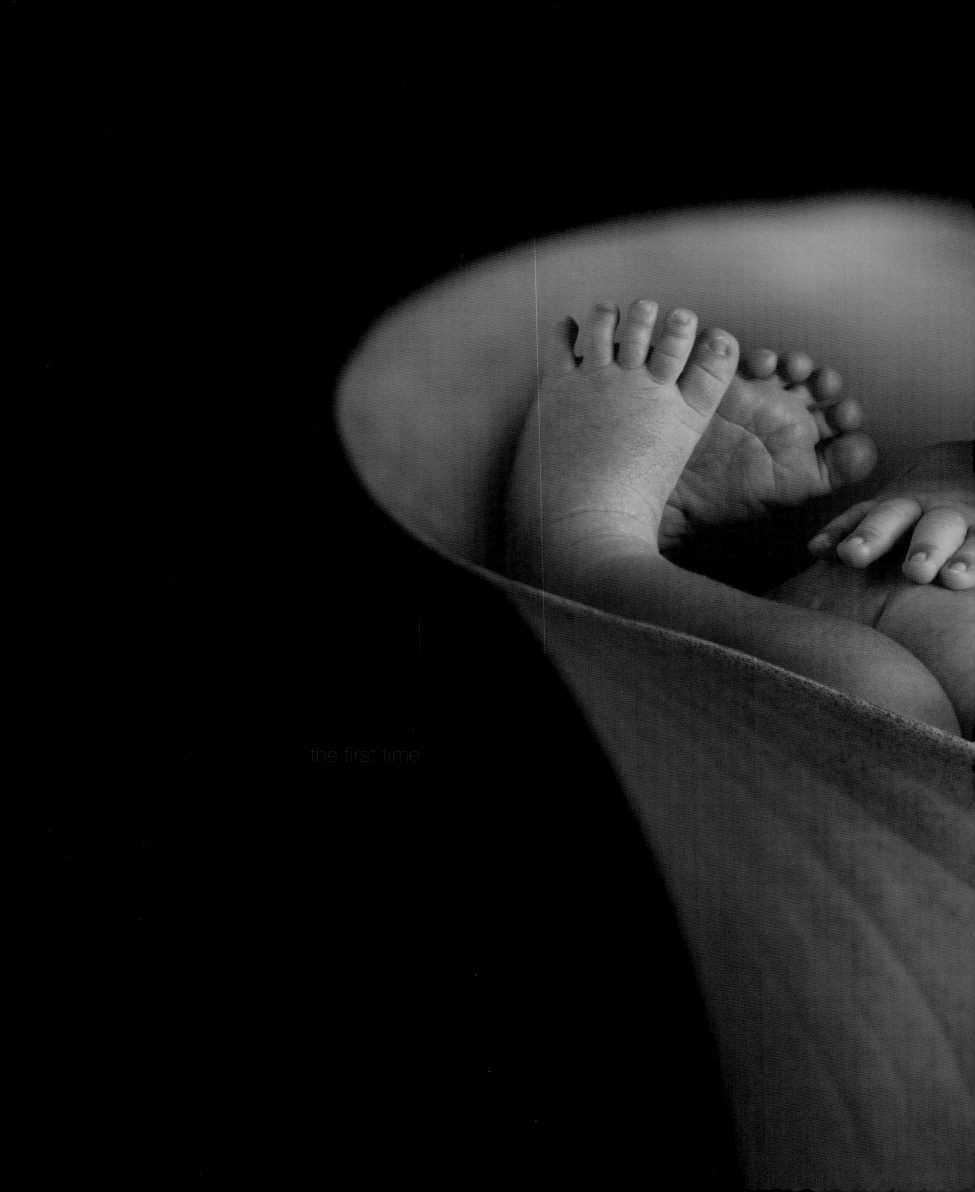

the first time

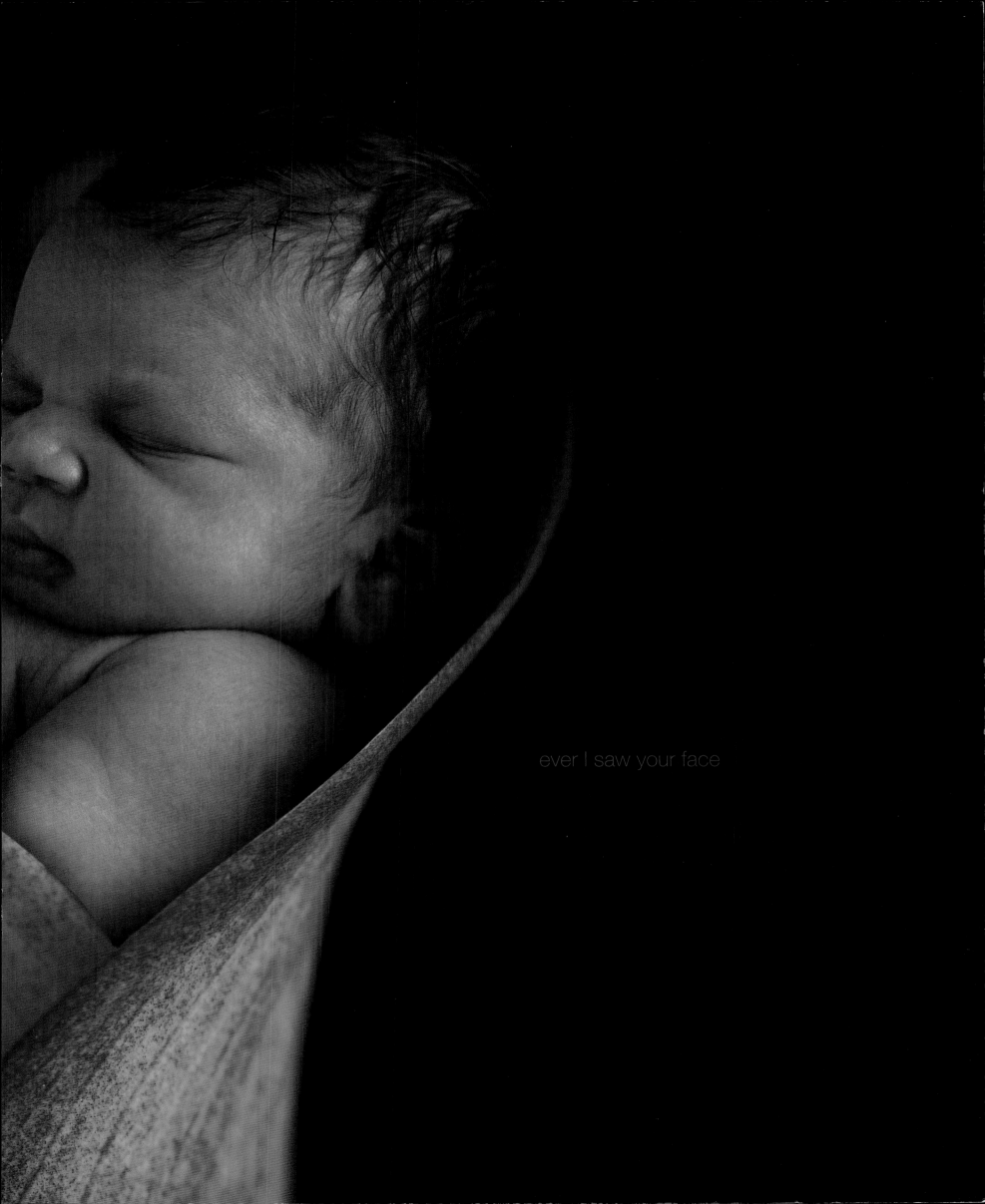

ever I saw your face

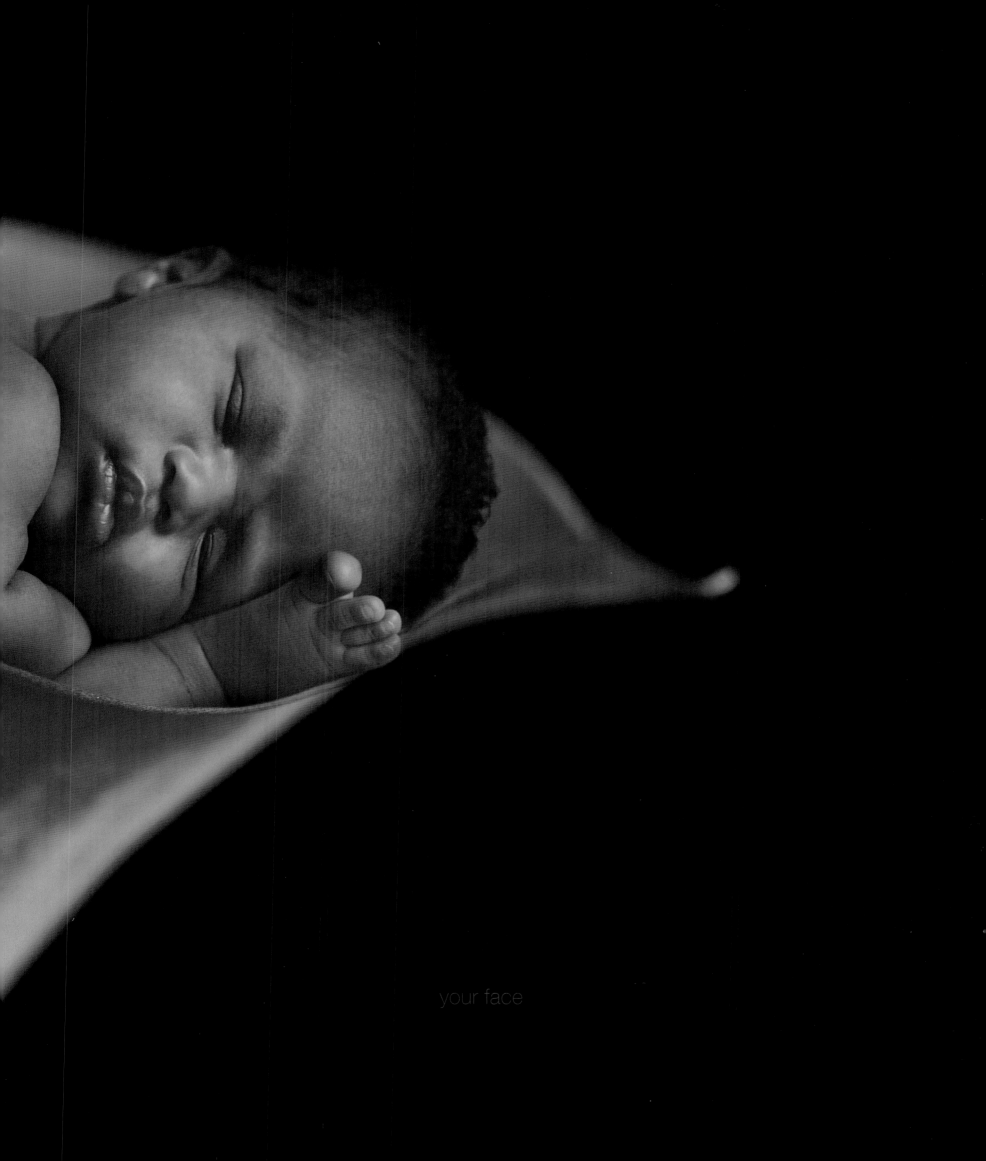

your face

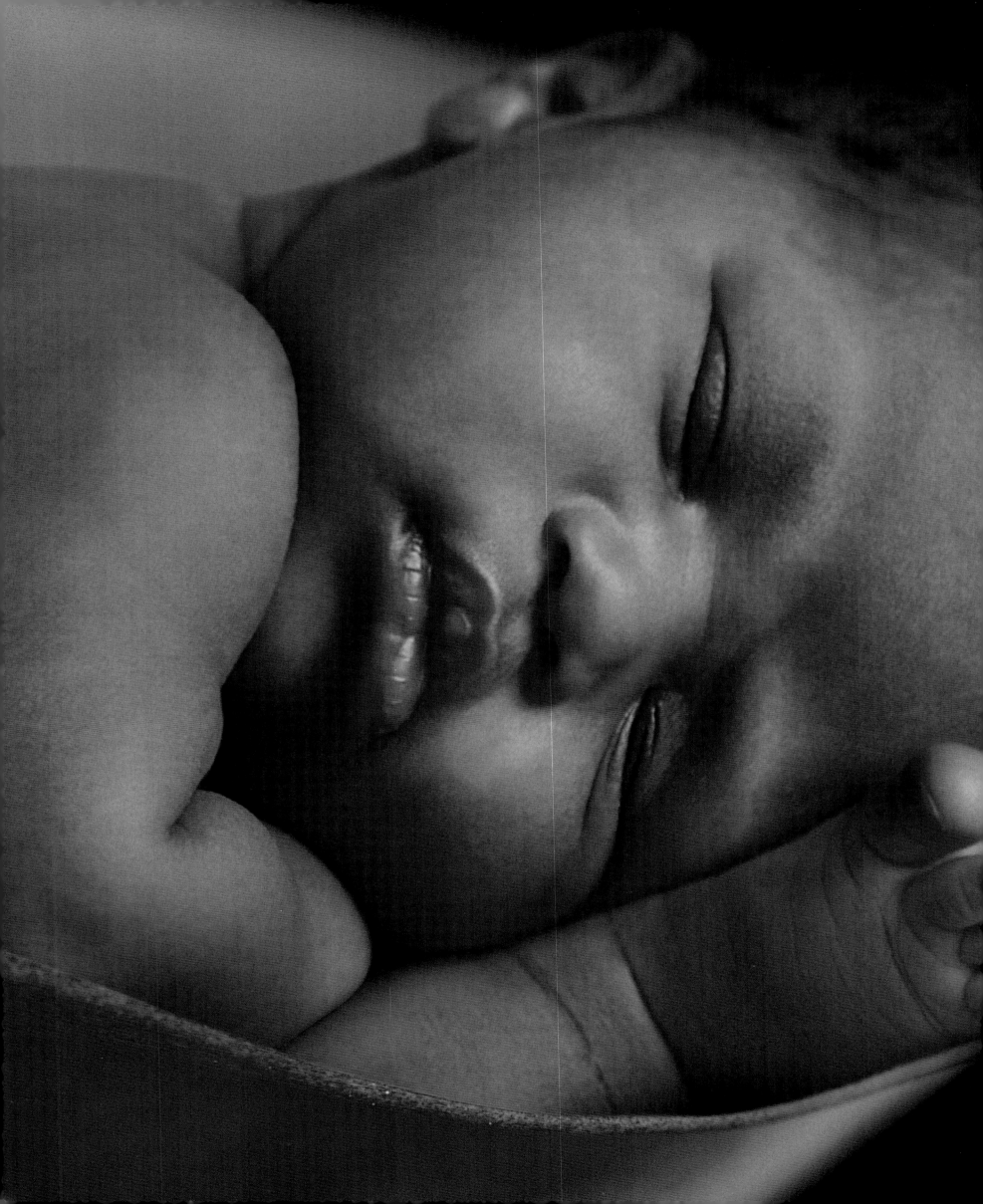

if I could

if I could
I'd protect you from the sadness in your eyes
give you courage in a world of compromise
yes, I would

if I could
I would teach you all the things I've never learned
and I'd help you cross the bridges that I've burned
yes, I would

if I could
I would try to shield your innocence from time
but the part of life I gave you isn't mine
I've watched you grow, so I could let you go

if I could
I would help you make it through the hungry years
but I know that I could never cry your tears
but I would
if I could

yes, if I live
in a time and place where you don't want to be
you don't have to walk along this road with me
my yesterday won't have to be your way

if I knew
I would try to change the world I brought you to
and there isn't very much that I could do
but I would
if I could

oh baby
I just want to protect you
and help my baby through the hungry years
'cause you're part of me
and if you ever ever ever need
I said a shoulder to cry on
or just someone to talk to
I'll be there, I'll be there

I didn't change your world
but I would
if I could

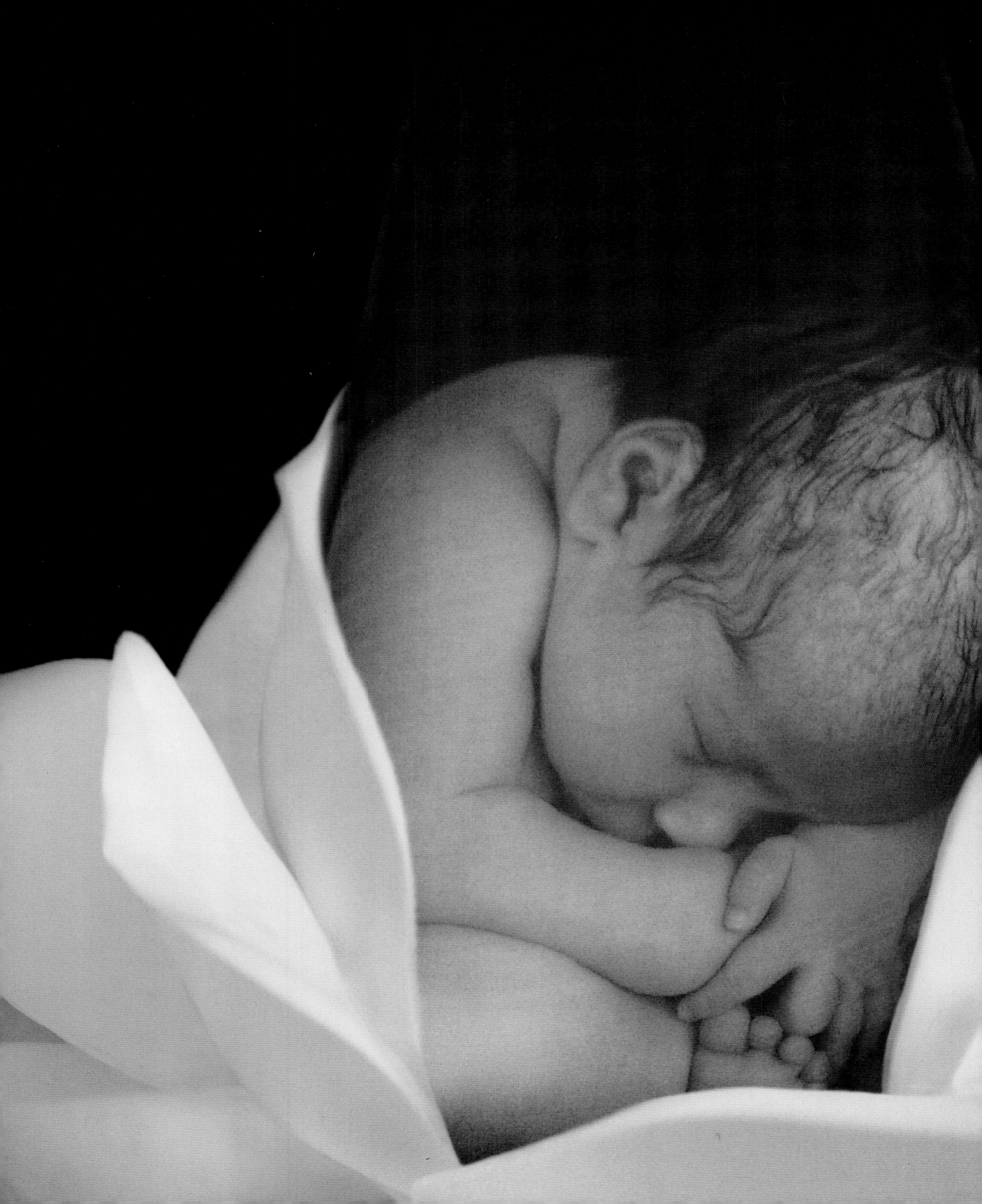

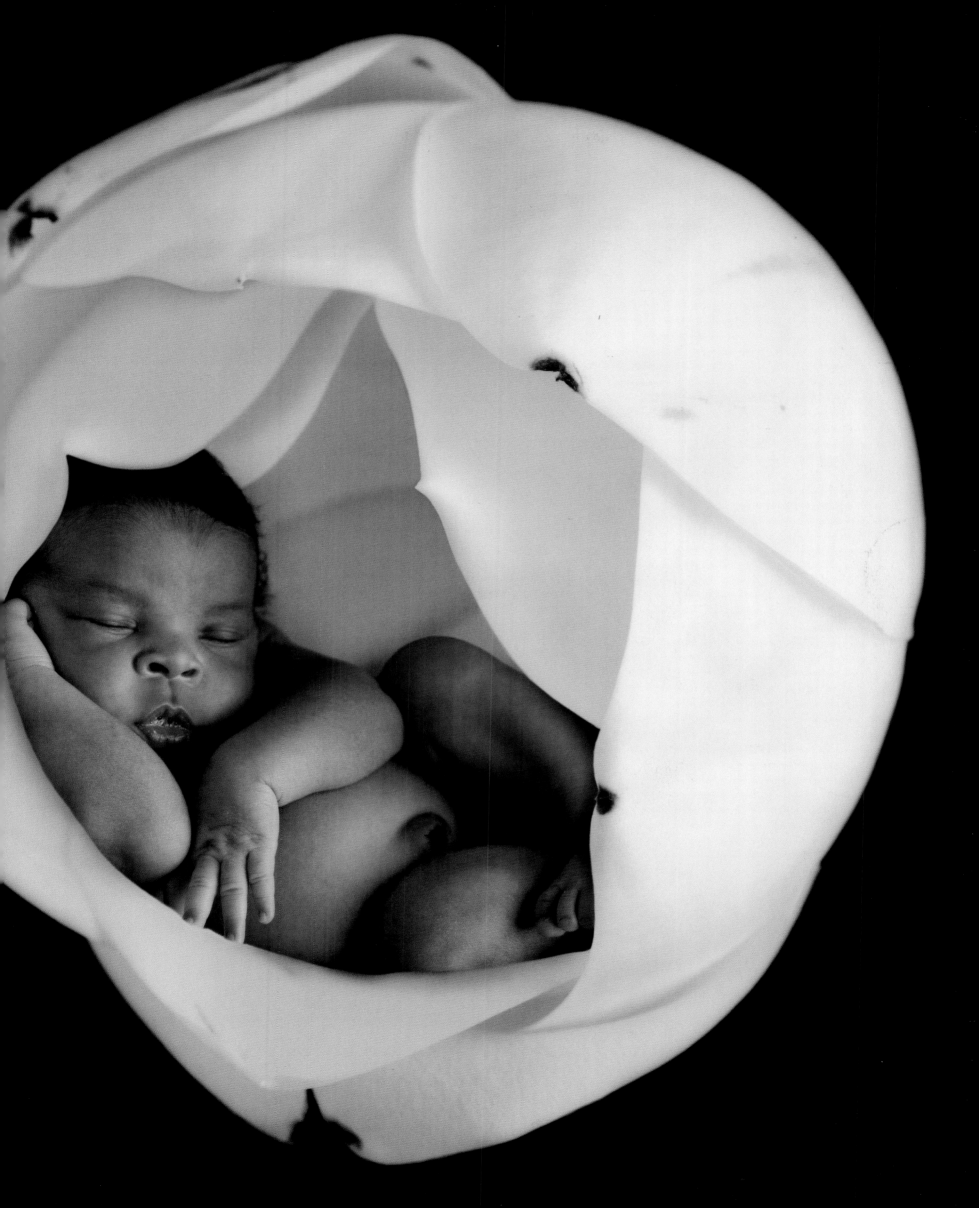

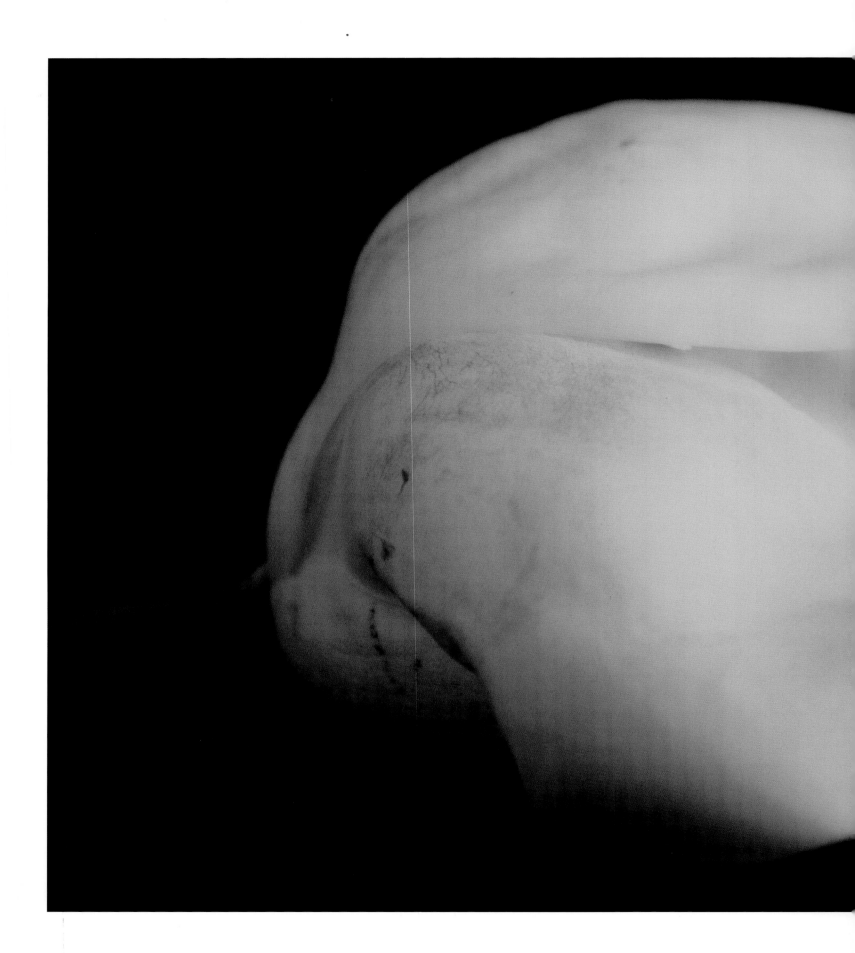

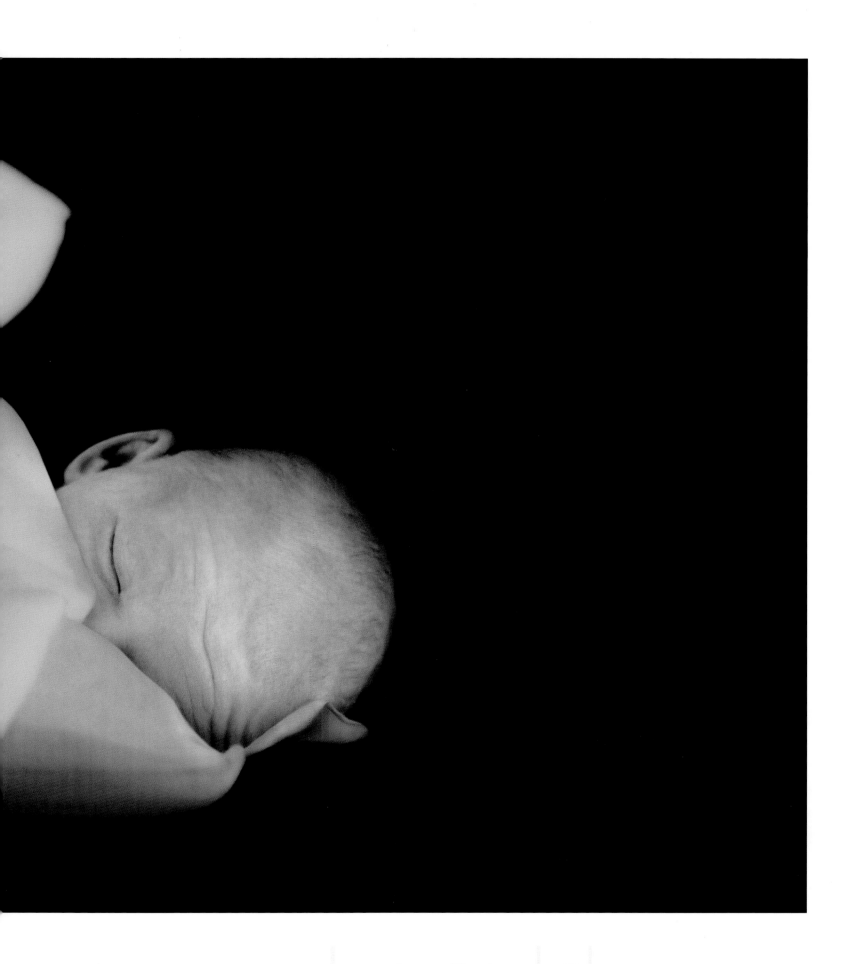

I would
teach you all the things I've never learned

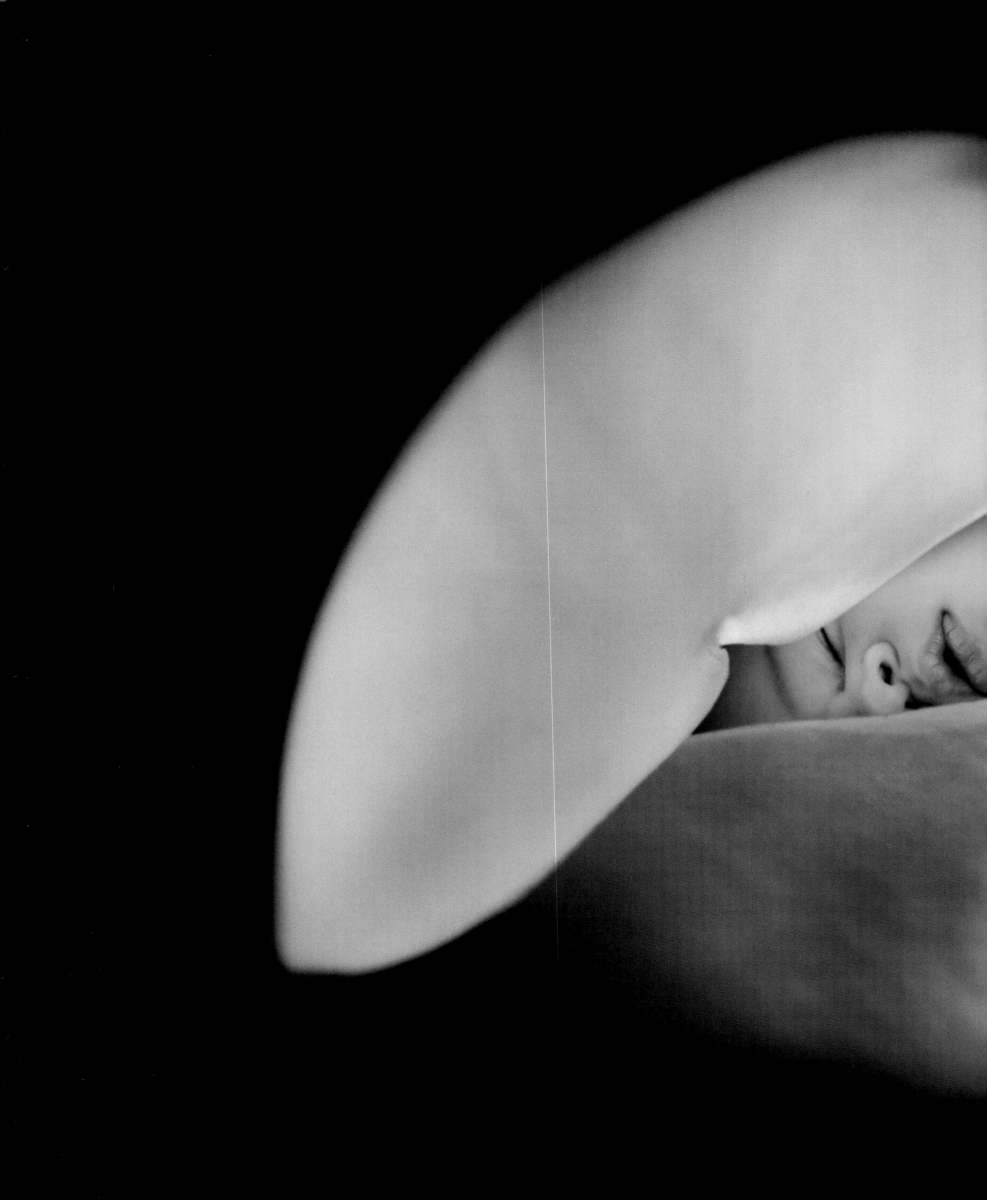

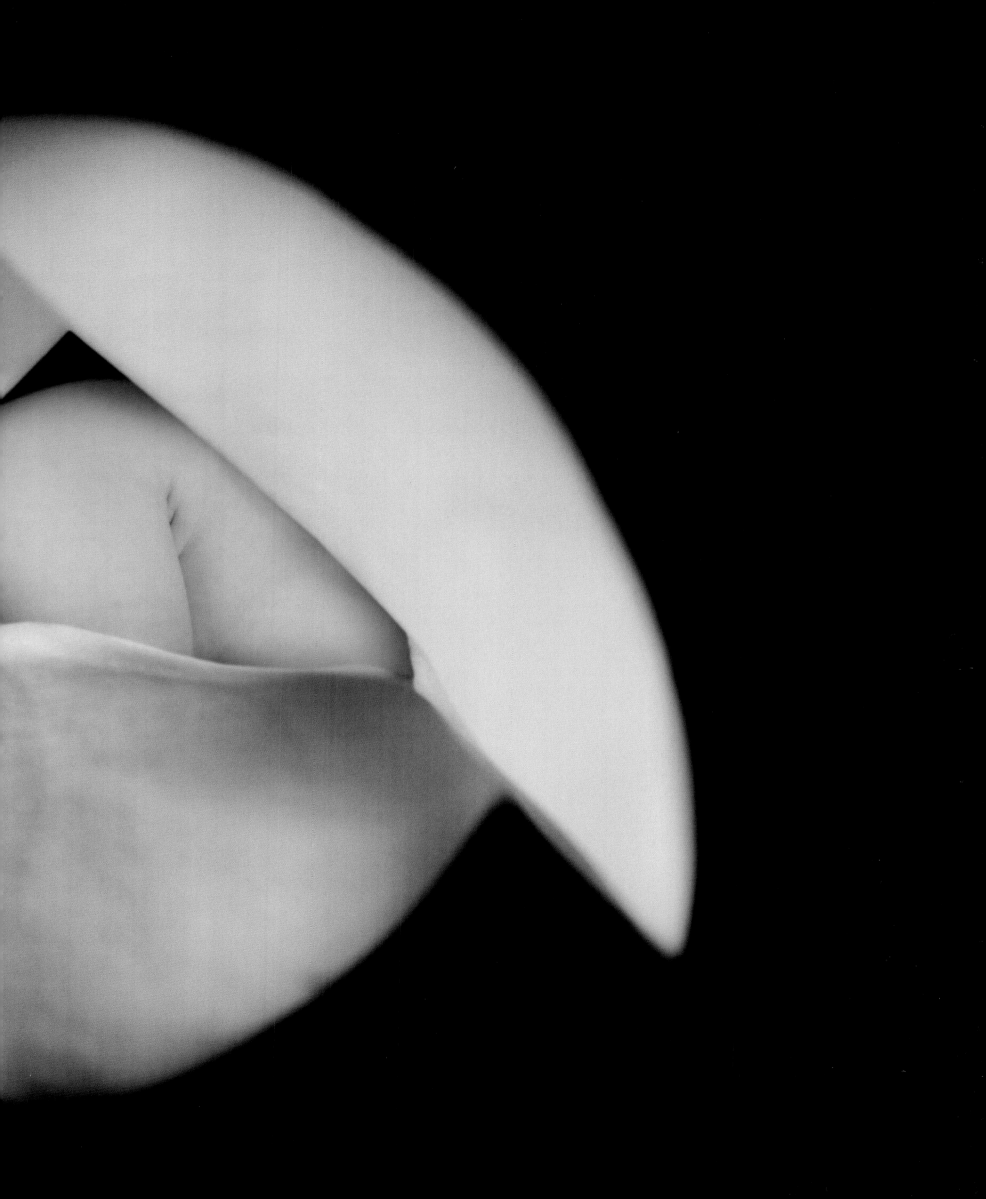

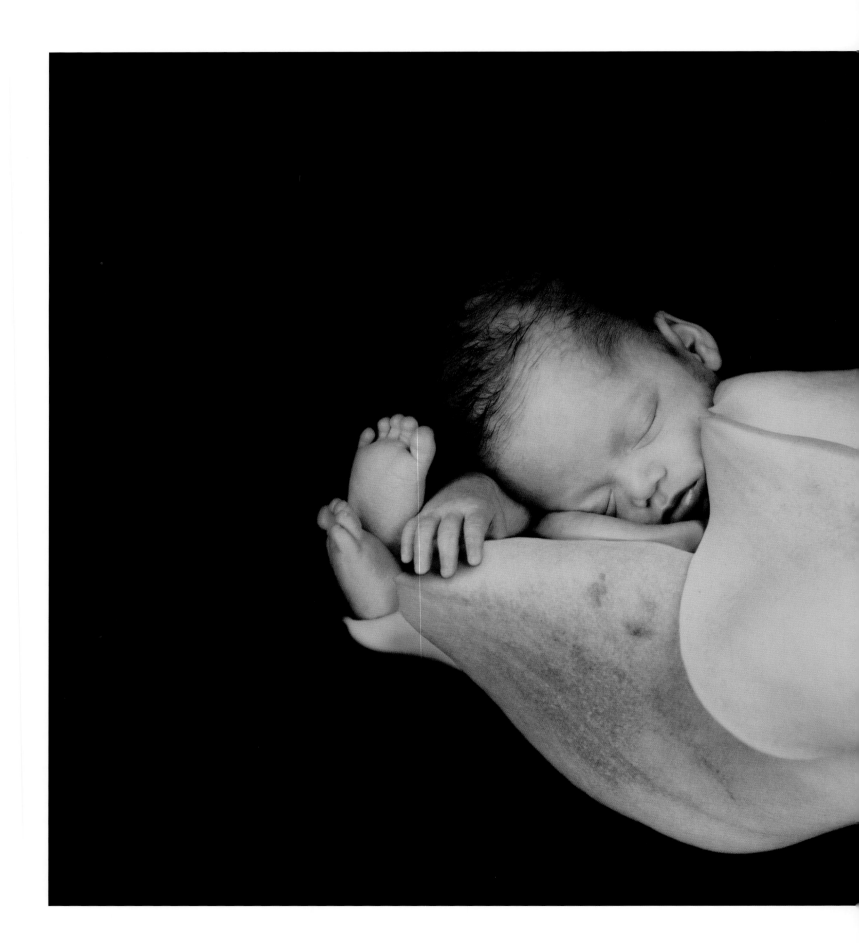

try to shield your innocence from time

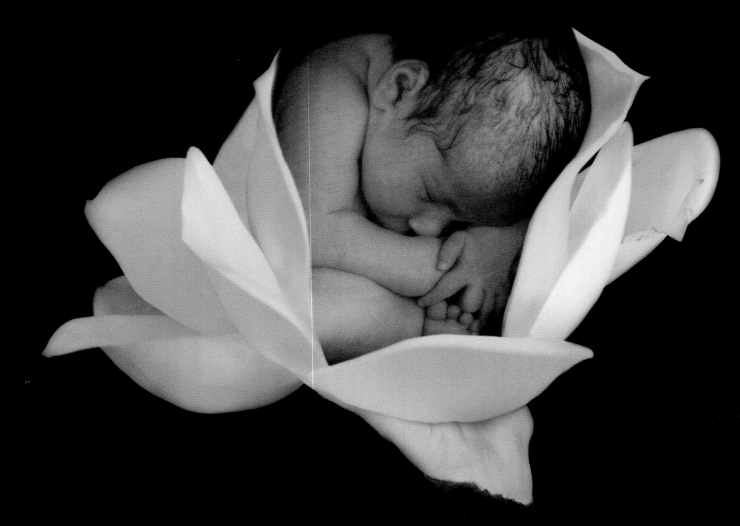

I've watched you

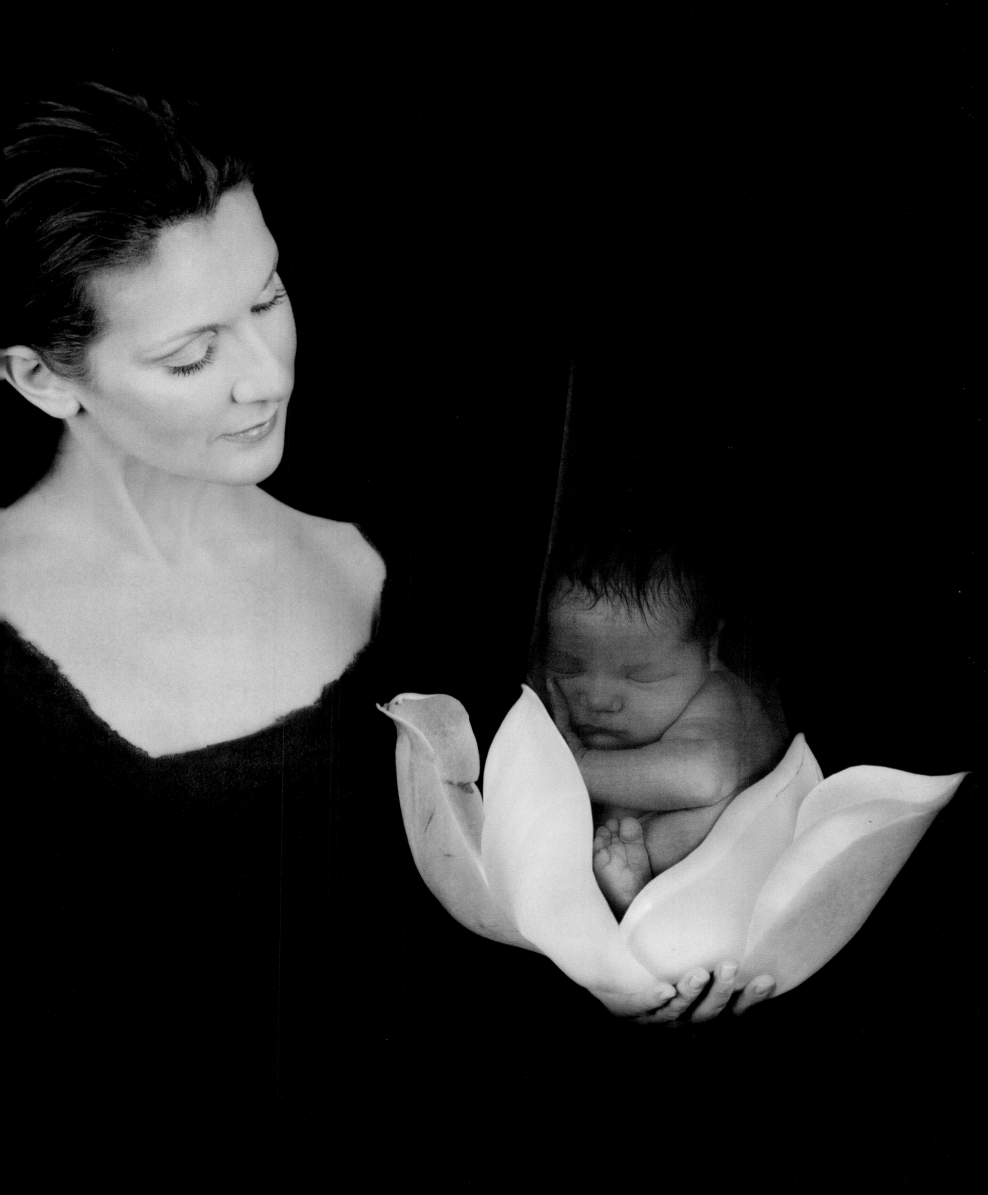

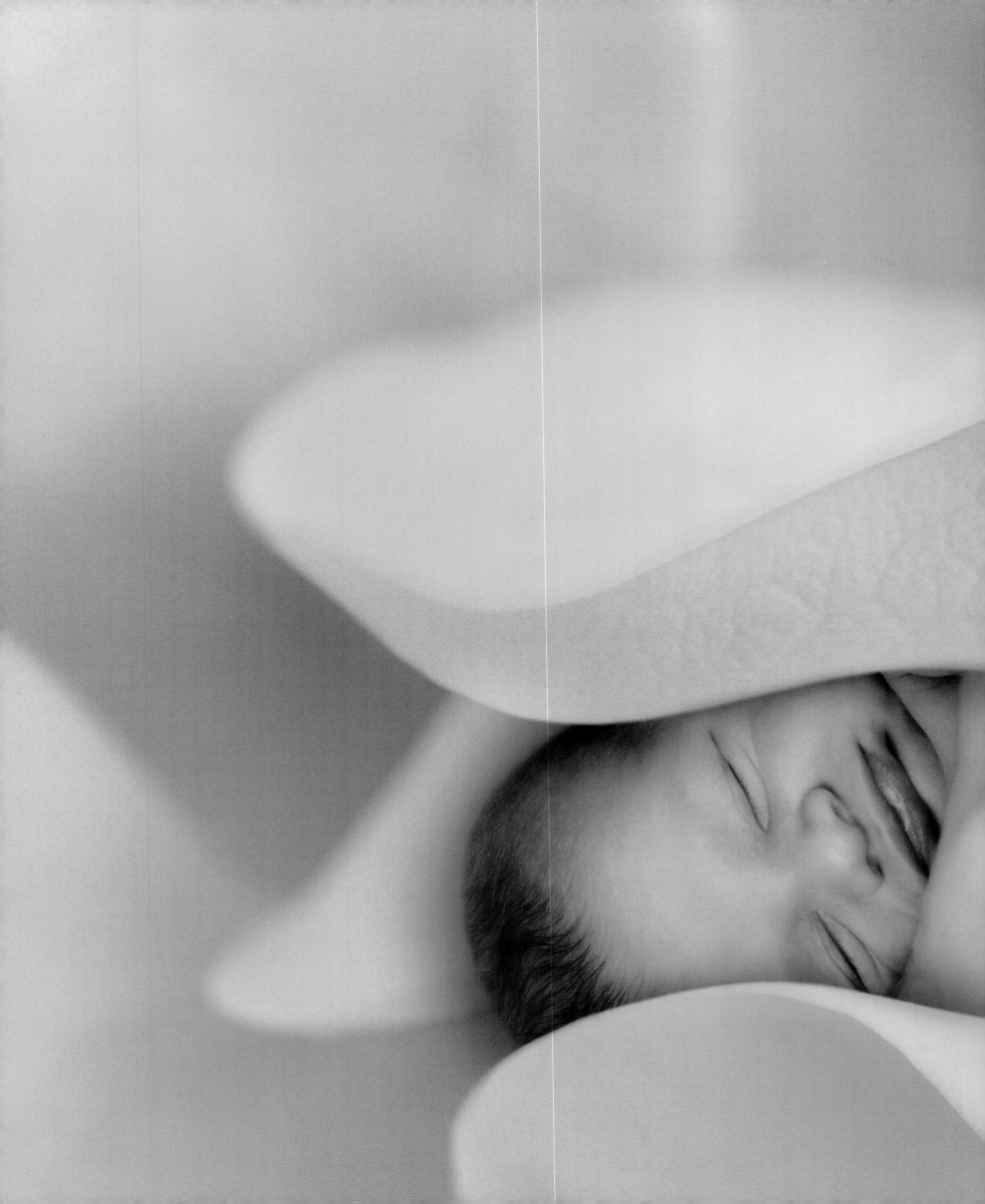

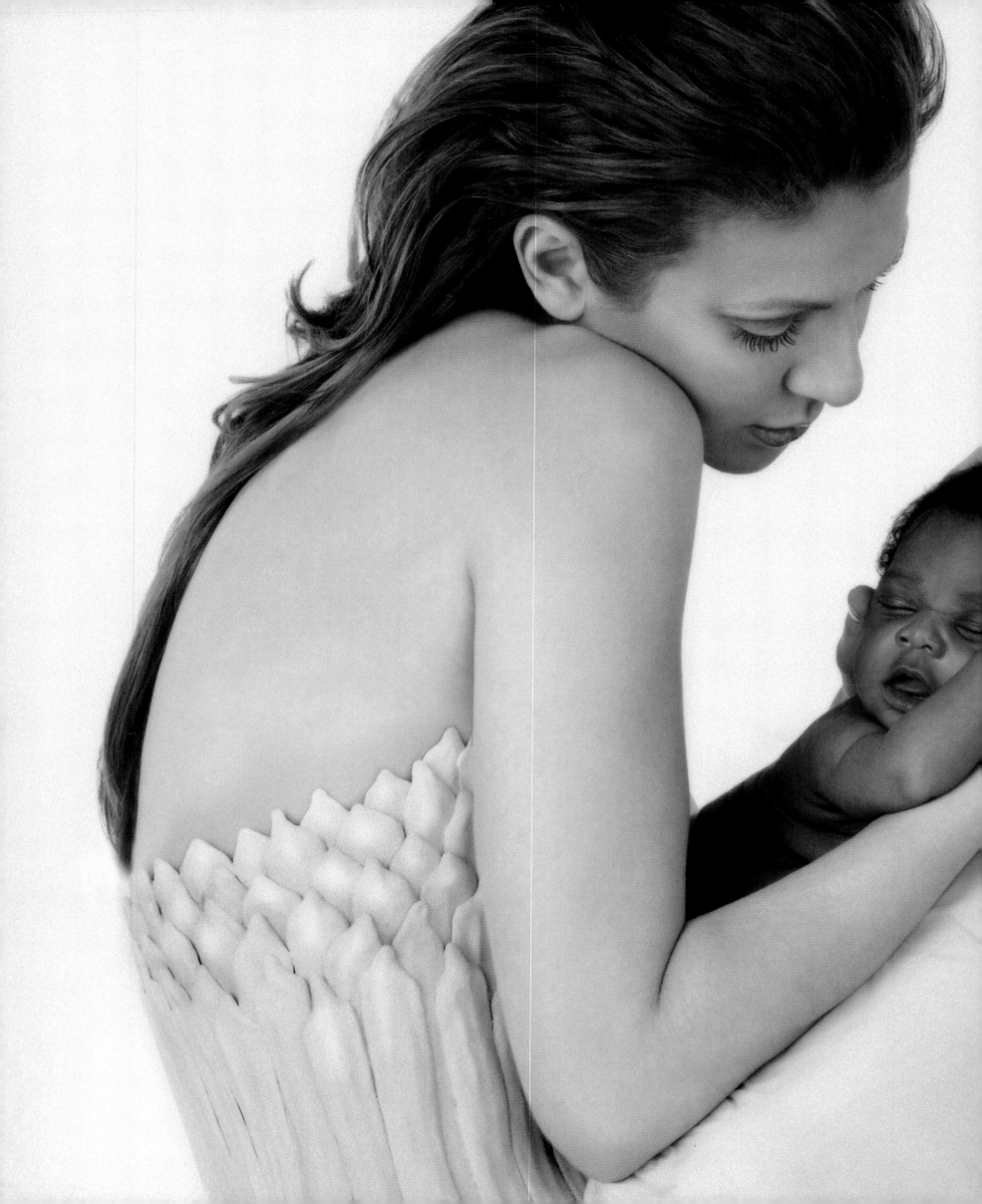

I know that I could never cry your tears but I would

if I could

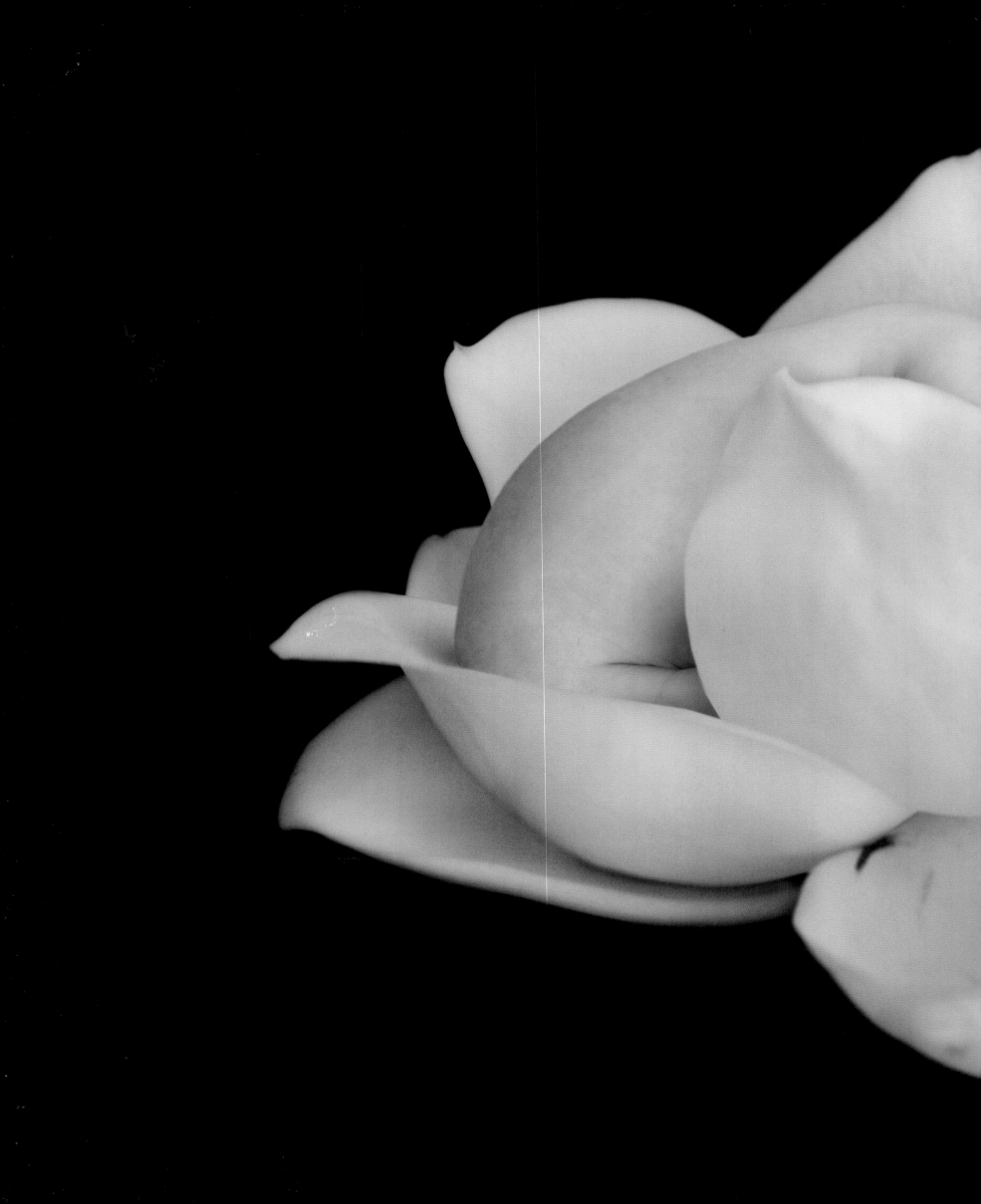

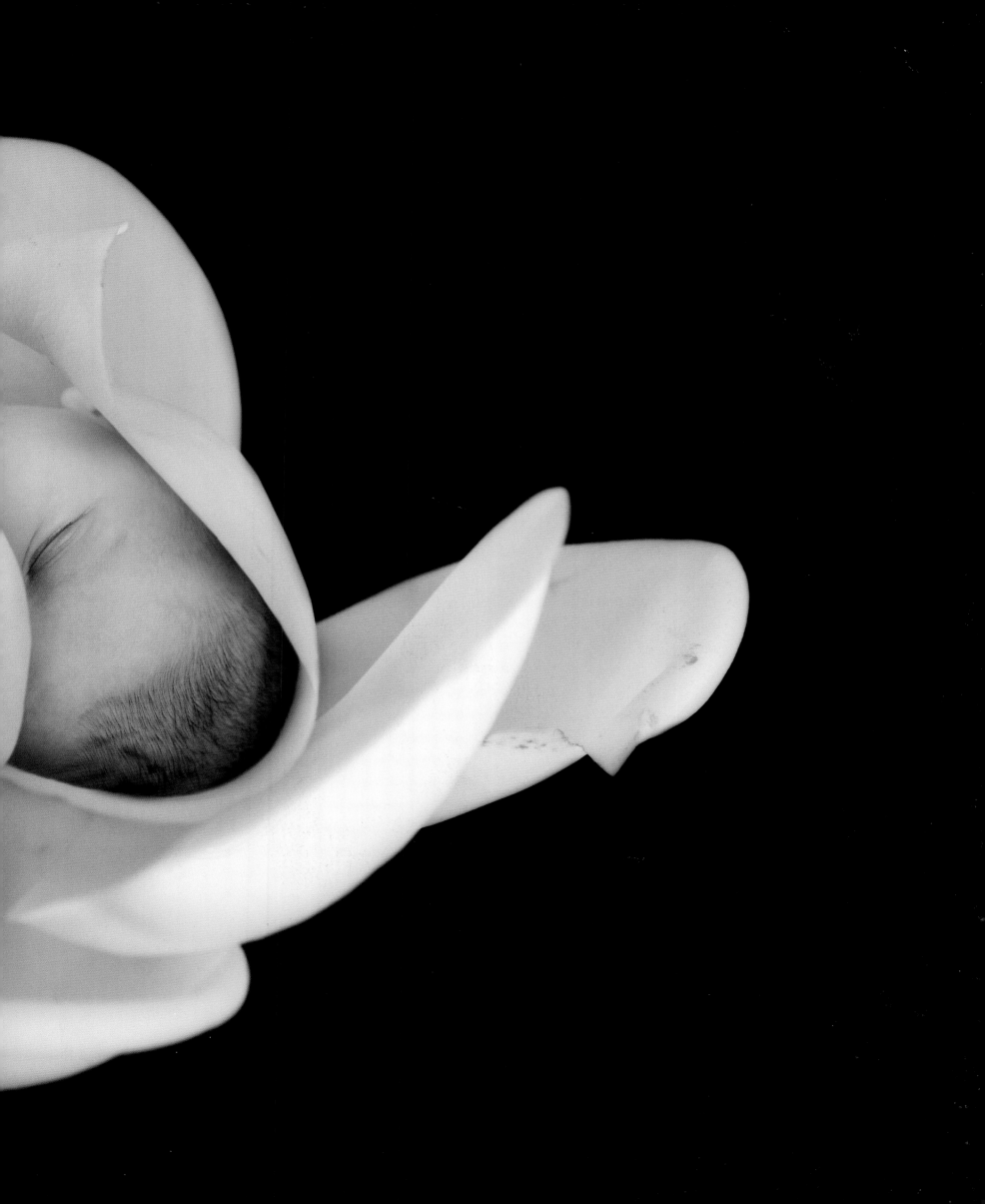

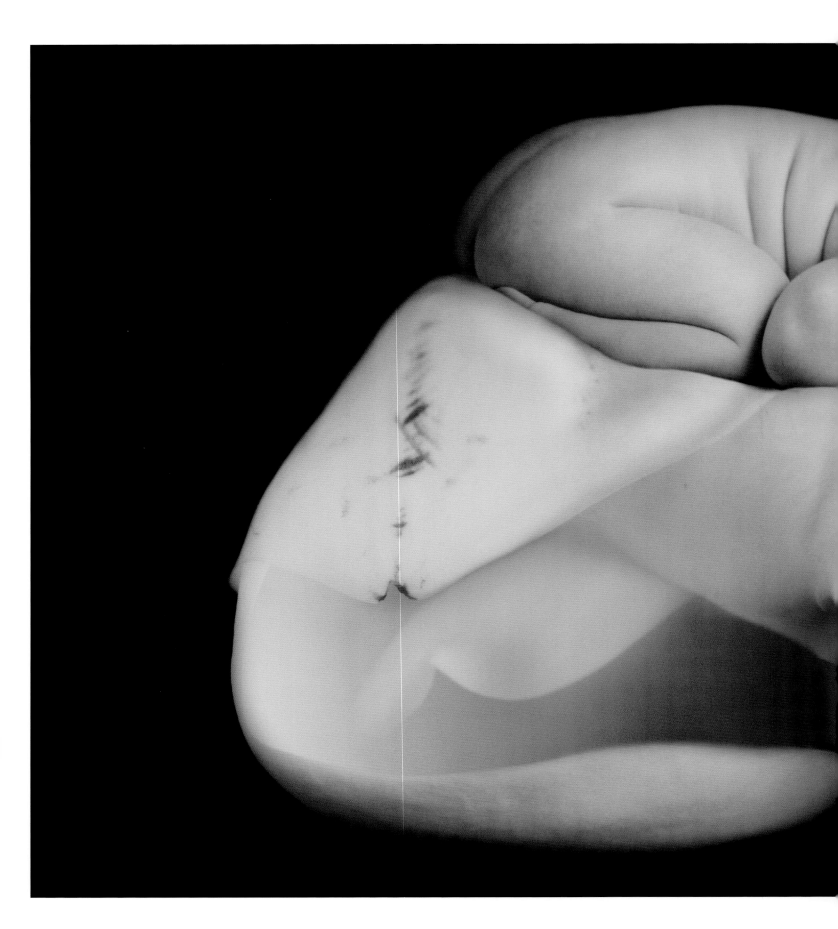

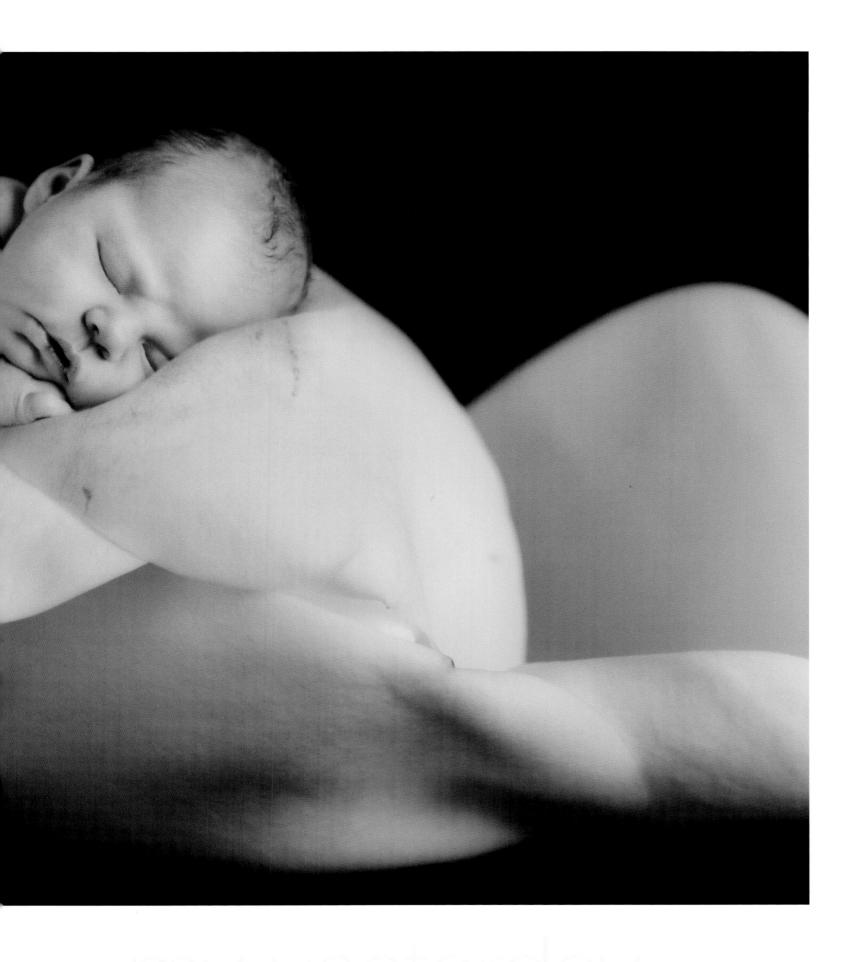

won't have to be your way

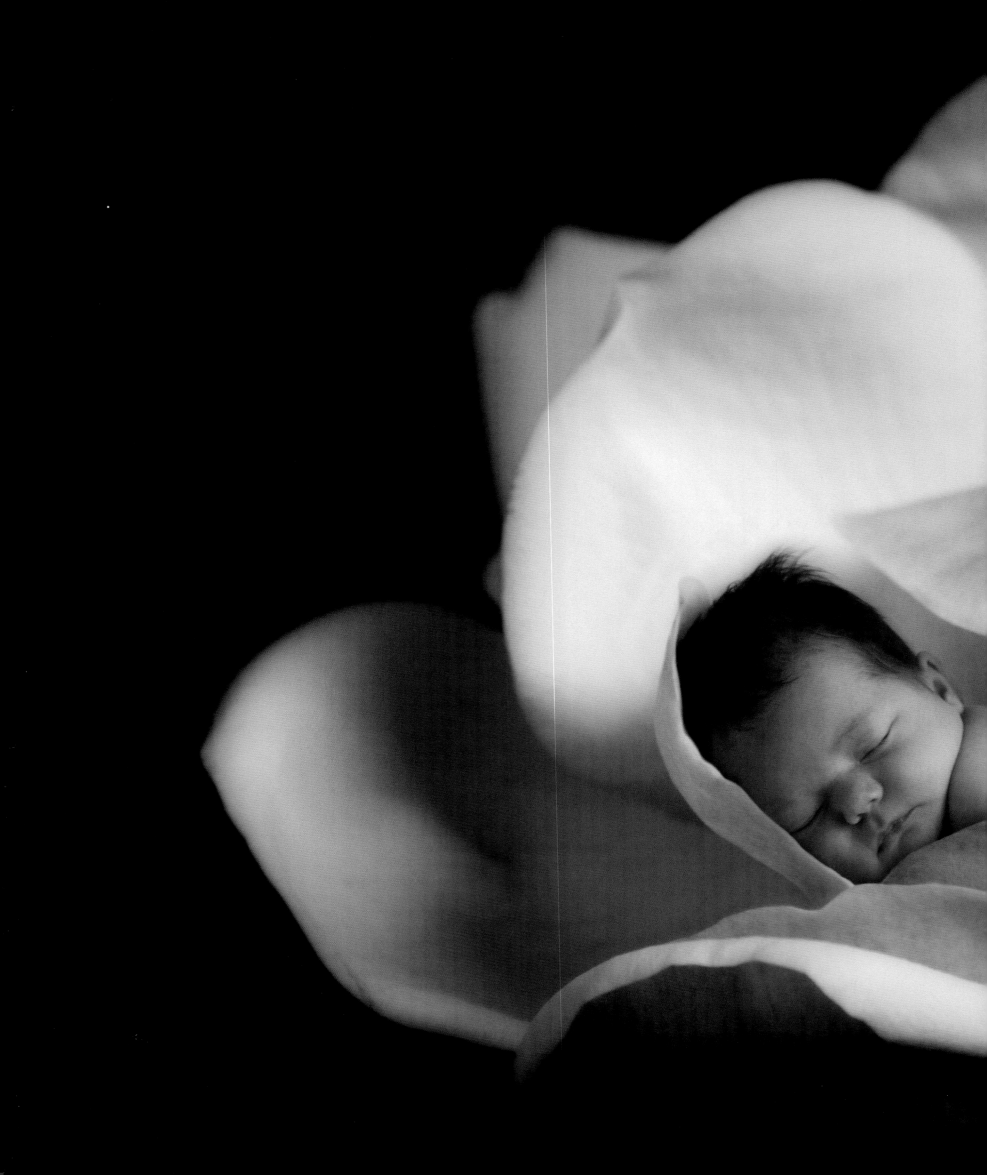

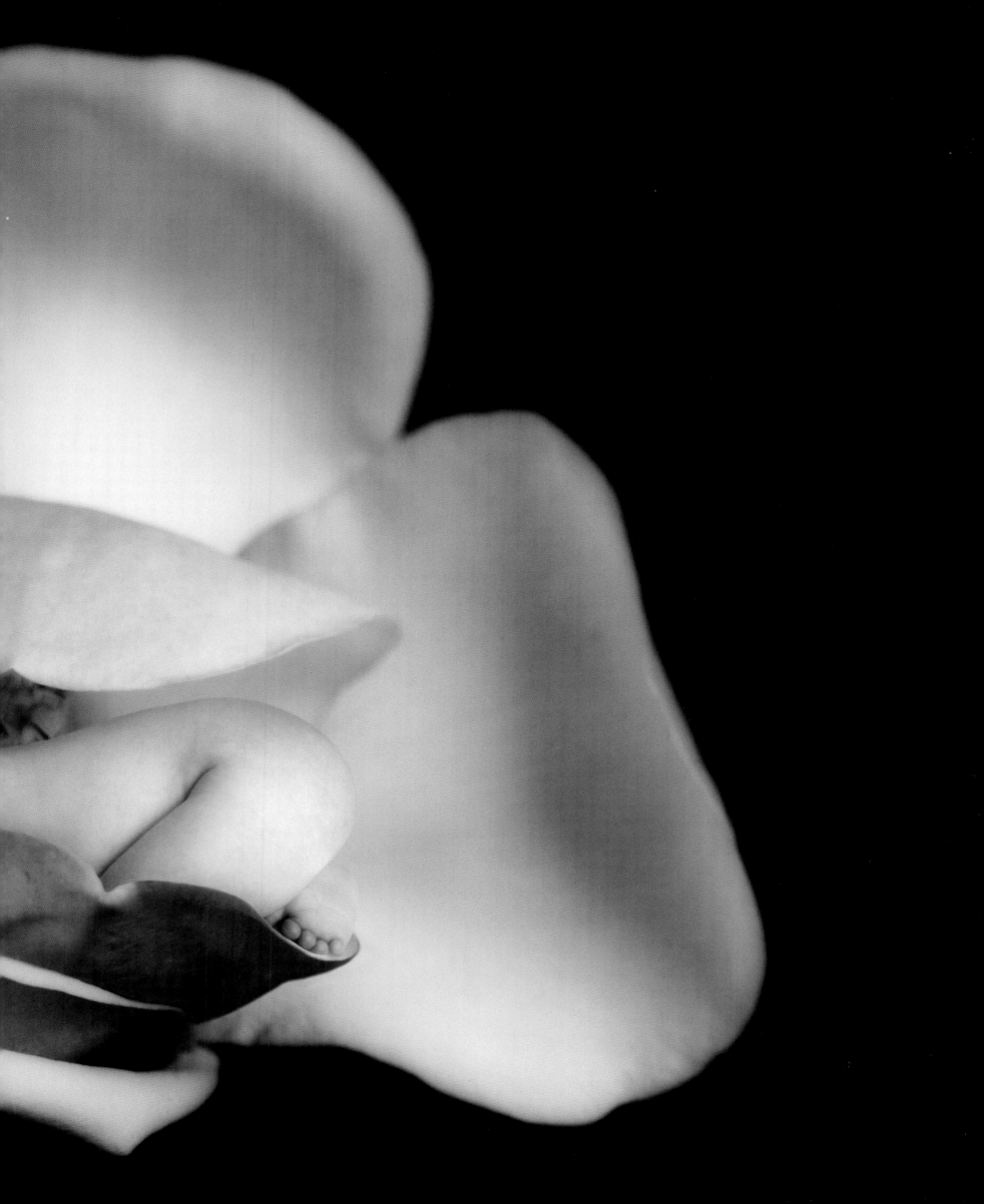

I would try to change the world I brought you to if I could

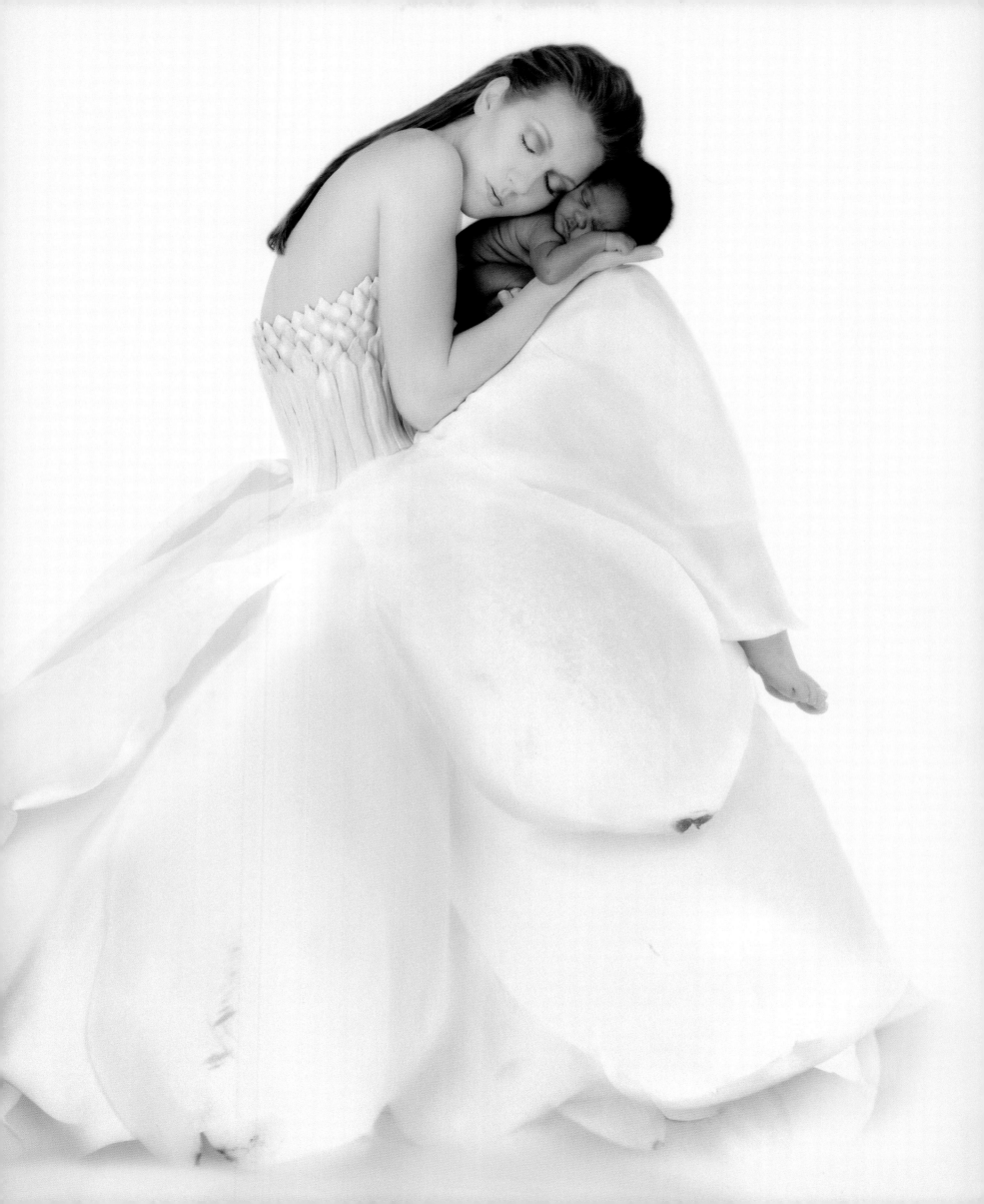

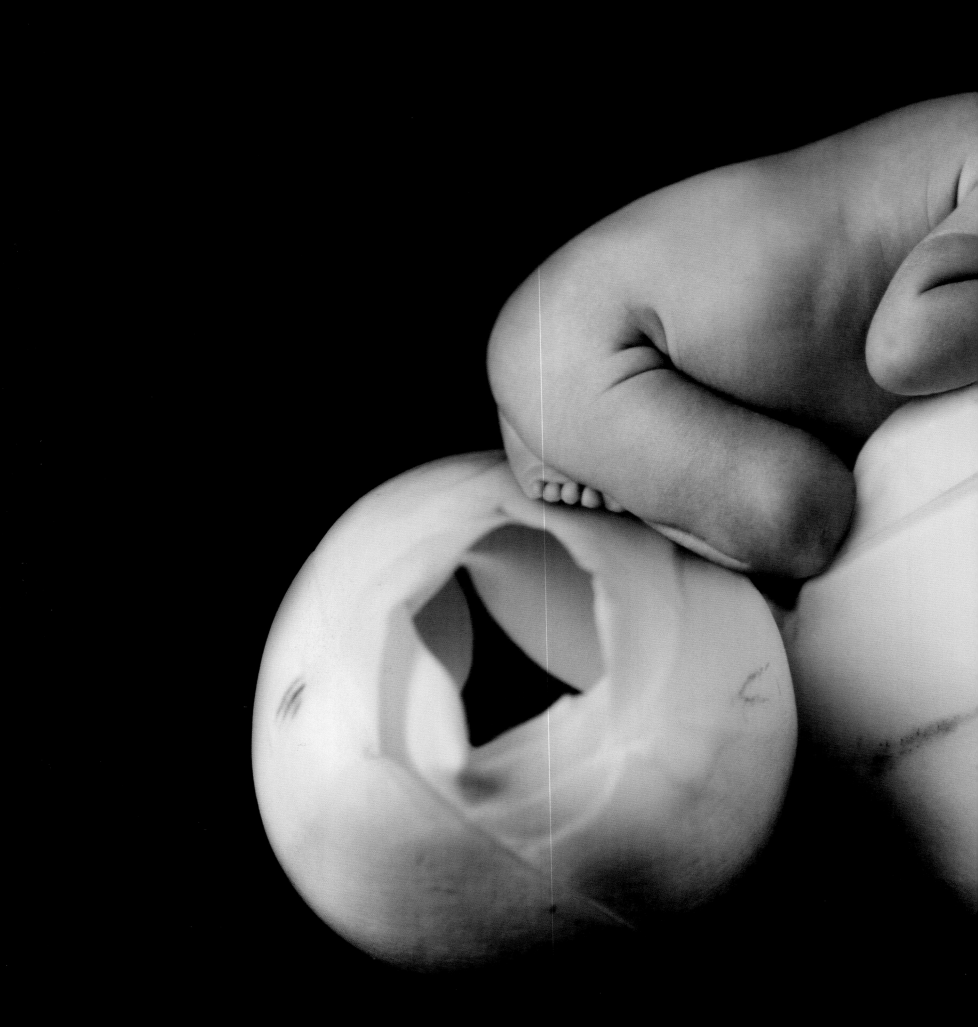

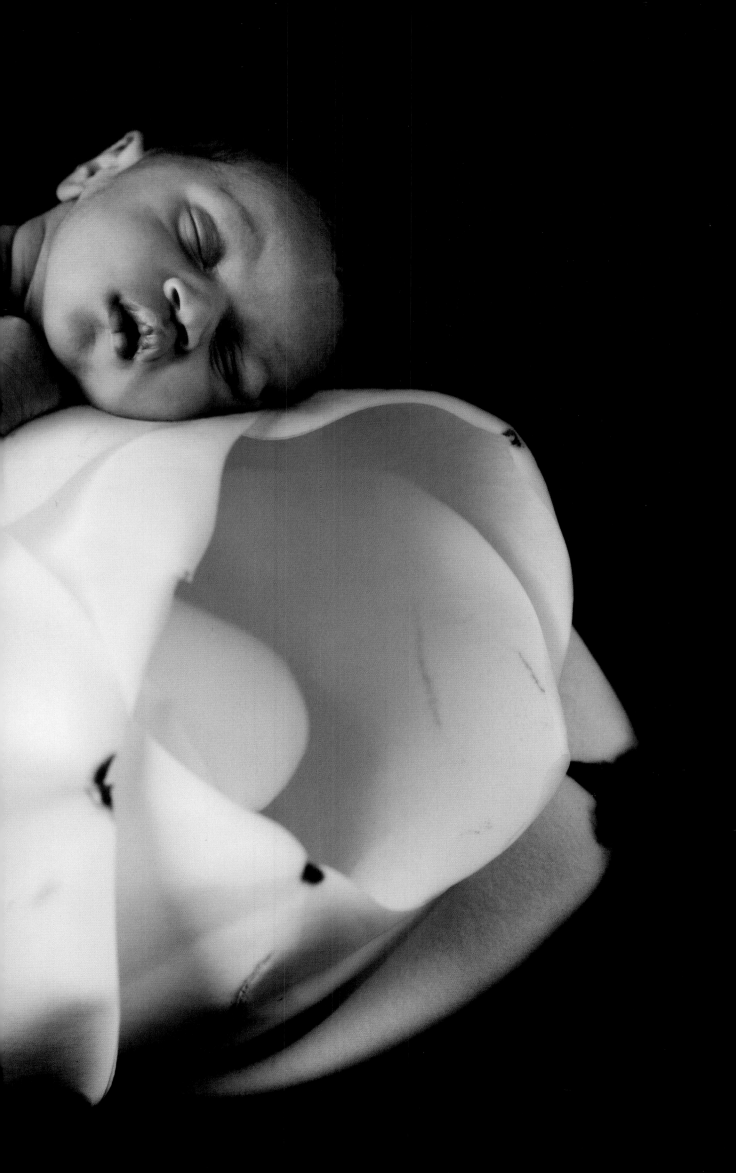

yes I would

what a wonderful world

I see trees of green, red roses too
I see them bloom for me and you
and I think to myself, what a wonderful world

I see skies of blue and clouds of white
the bright blessed day, dark sacred night
and I think to myself, what a wonderful world

the colors of the rainbow, so pretty in the sky
are also on the faces of people going by
I see friends shaking hands, saying "how do you do?"
they're really saying "I love you"

I hear babies crying, I watch them grow
they'll learn much more than I'll ever know
and I think to myself, what a wonderful world
yes, I think to myself, what a wonderful world

I see trees of green, red roses too
I see them bloom for me and you
and I think to myself, what a wonderful world

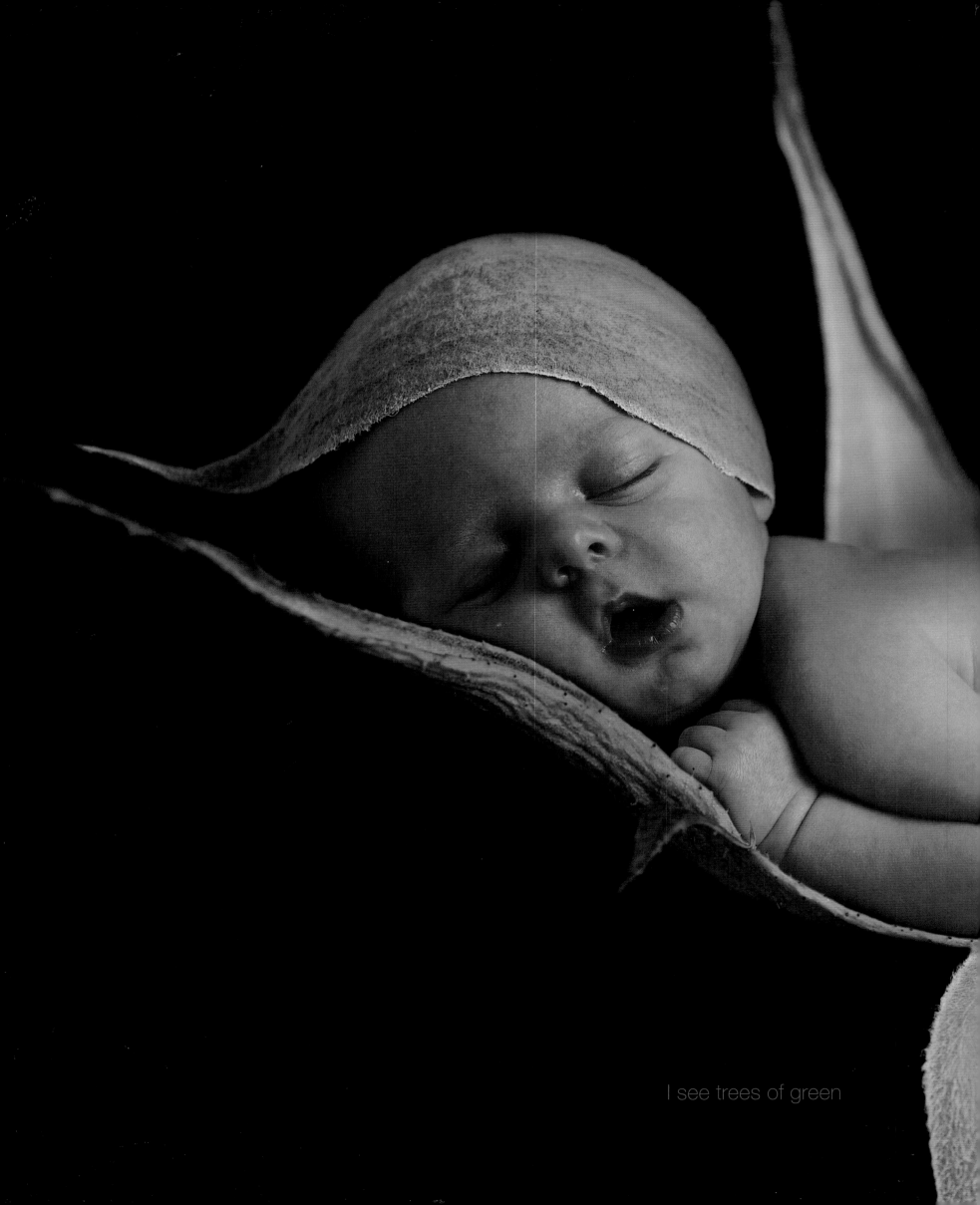

I see trees of green

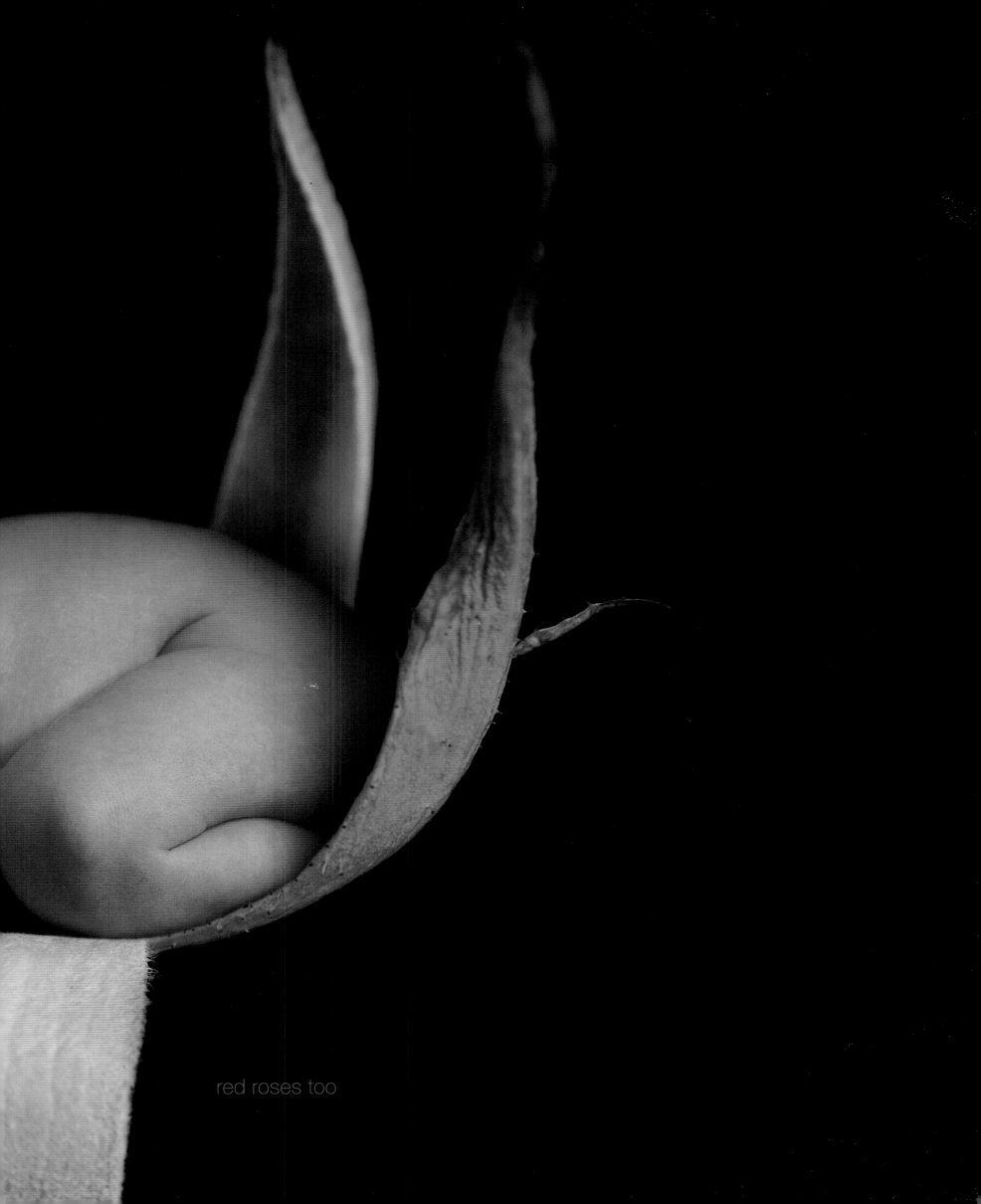

red roses too

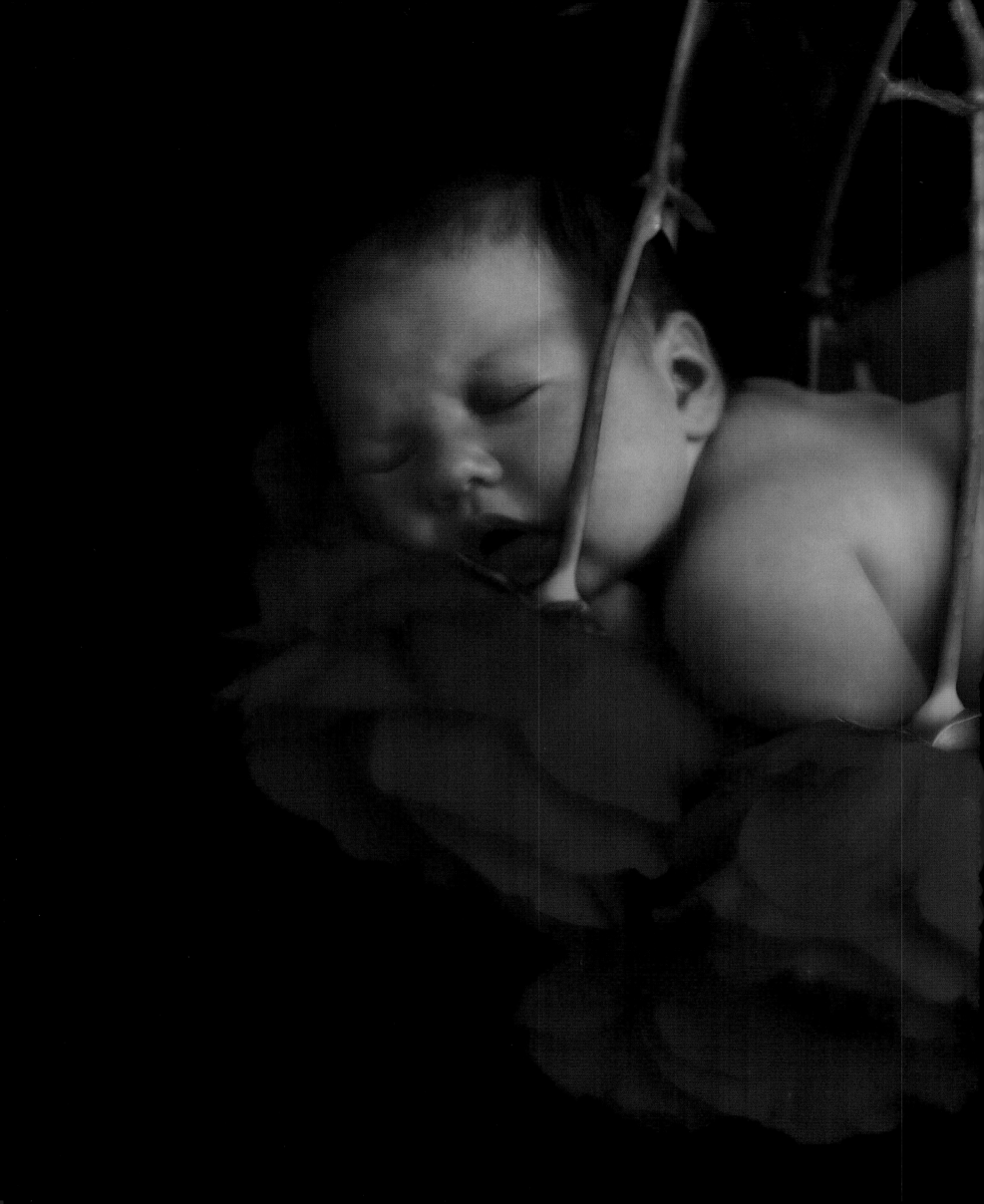

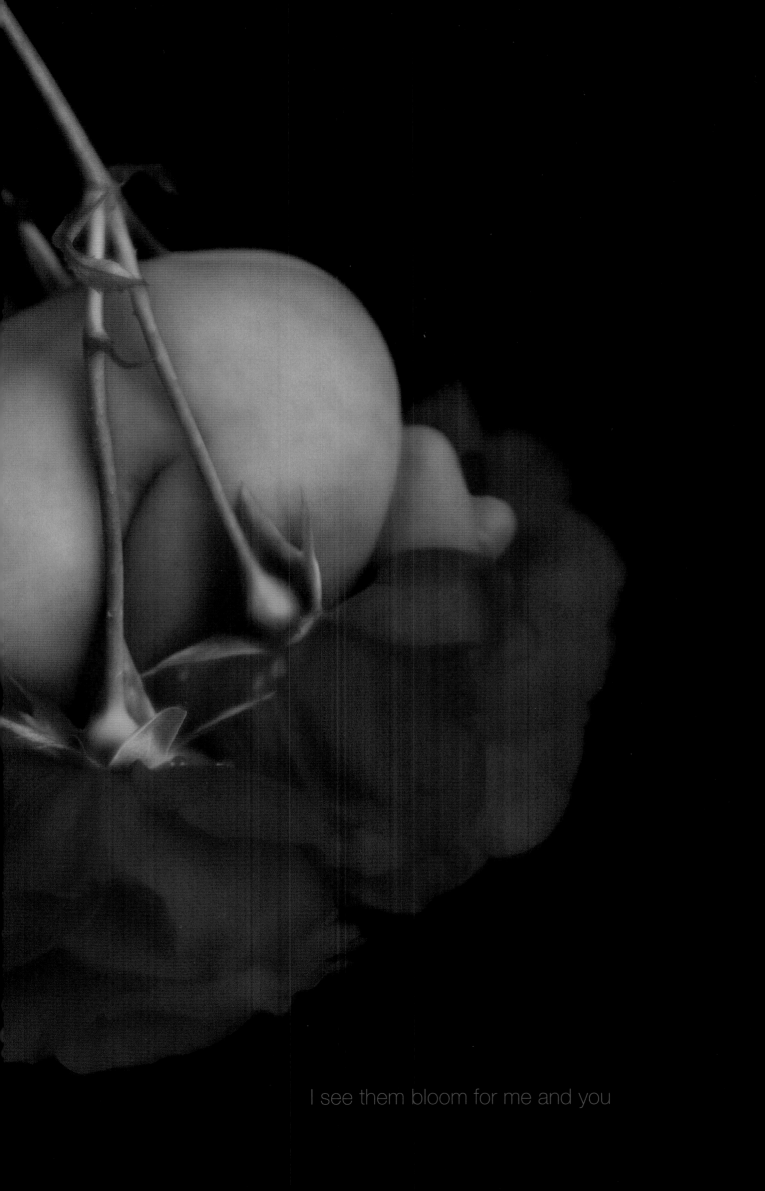

I see them bloom for me and you

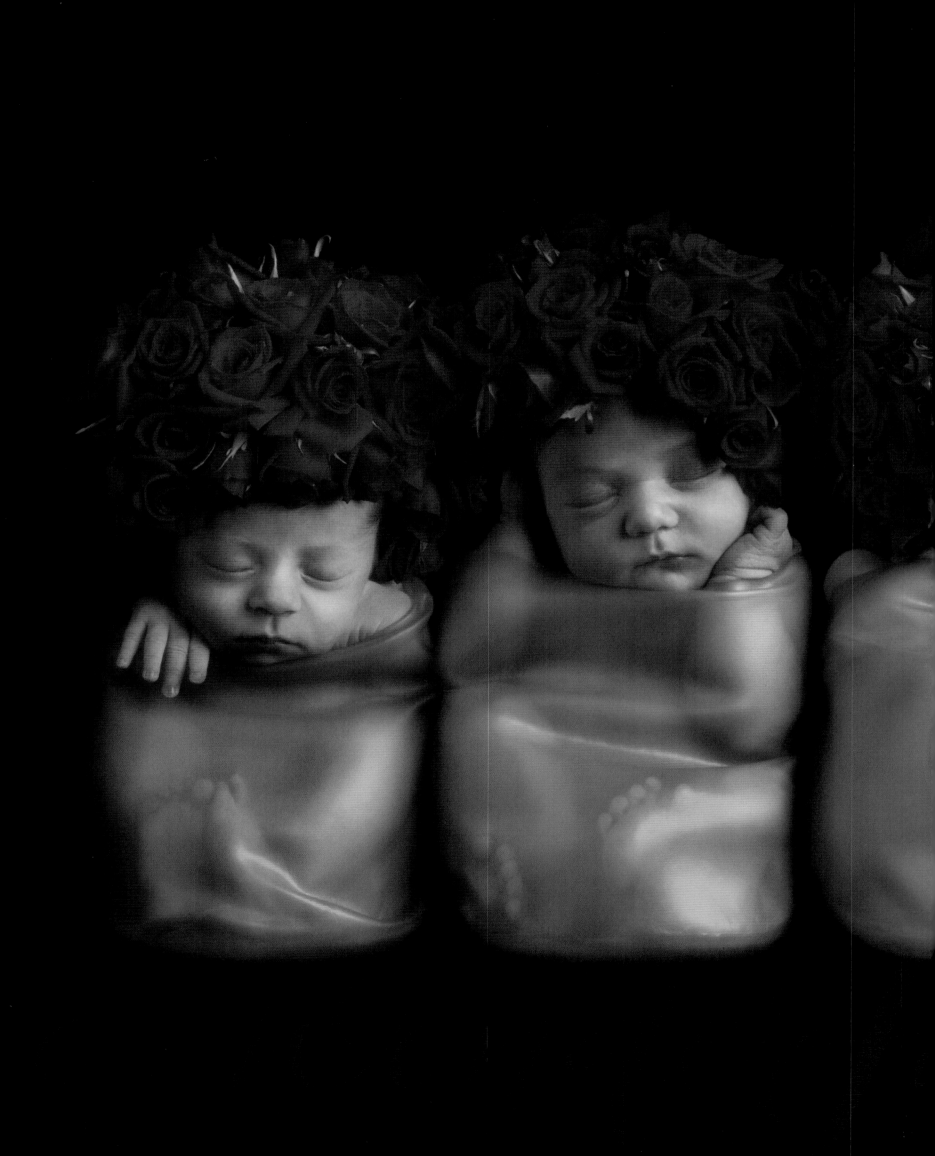

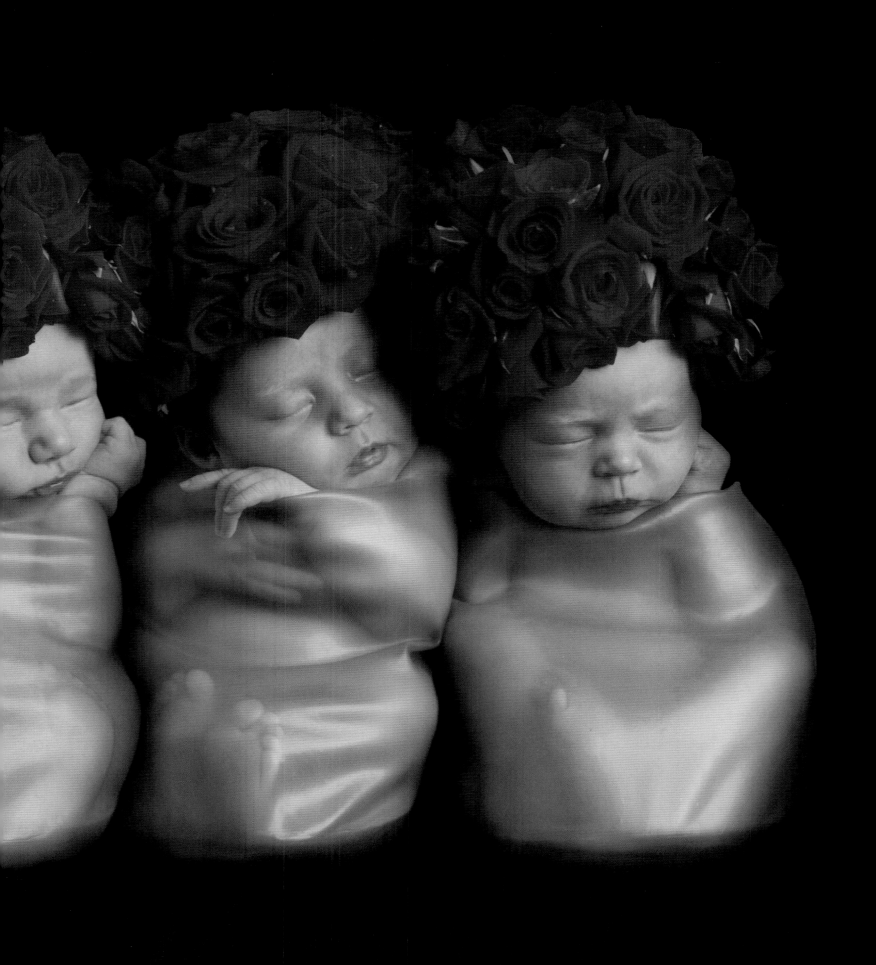

and I think to myself, what a wonderful world

I see skies of blue

and clouds of white

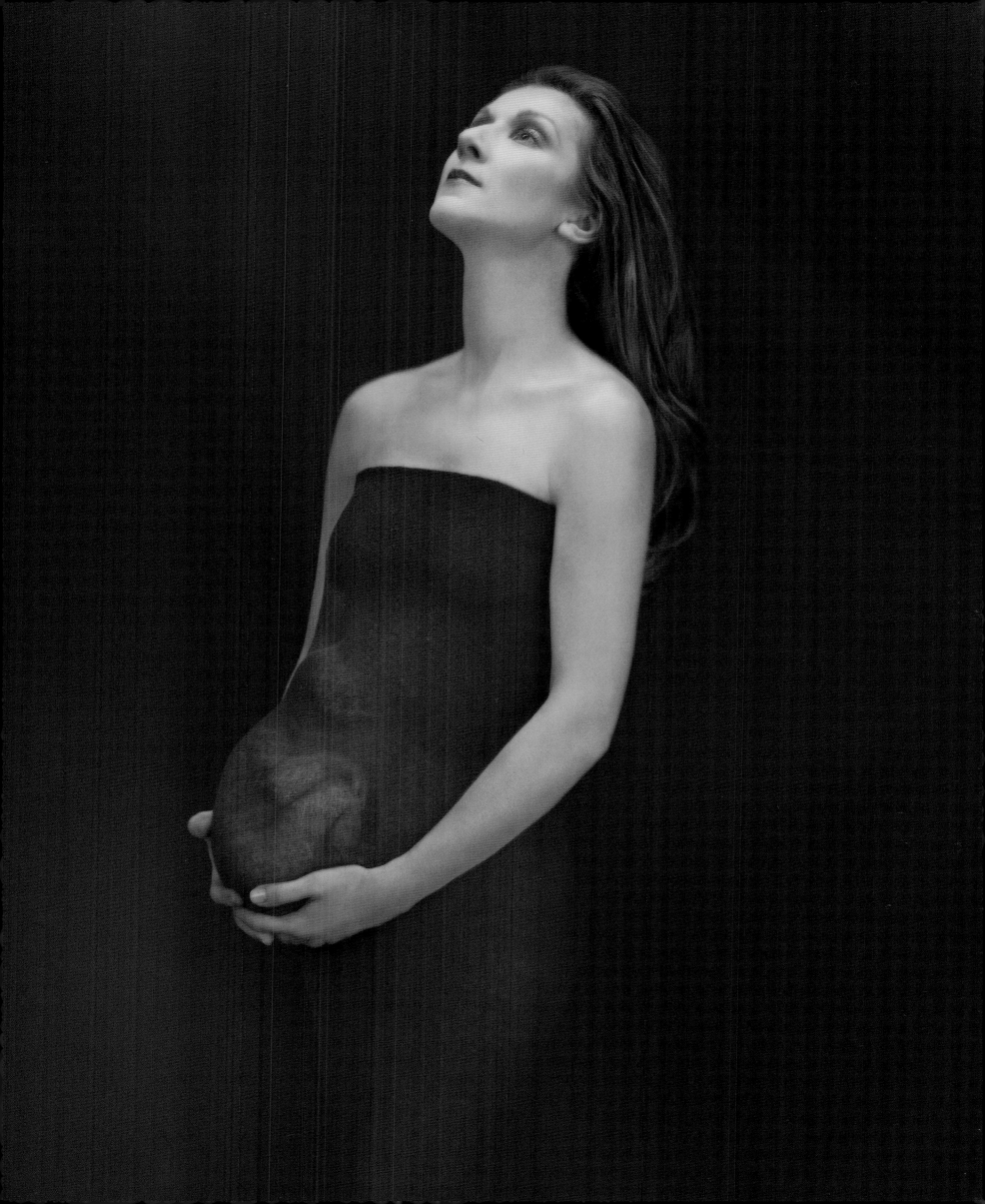

and I think to myself

what a wonderful world

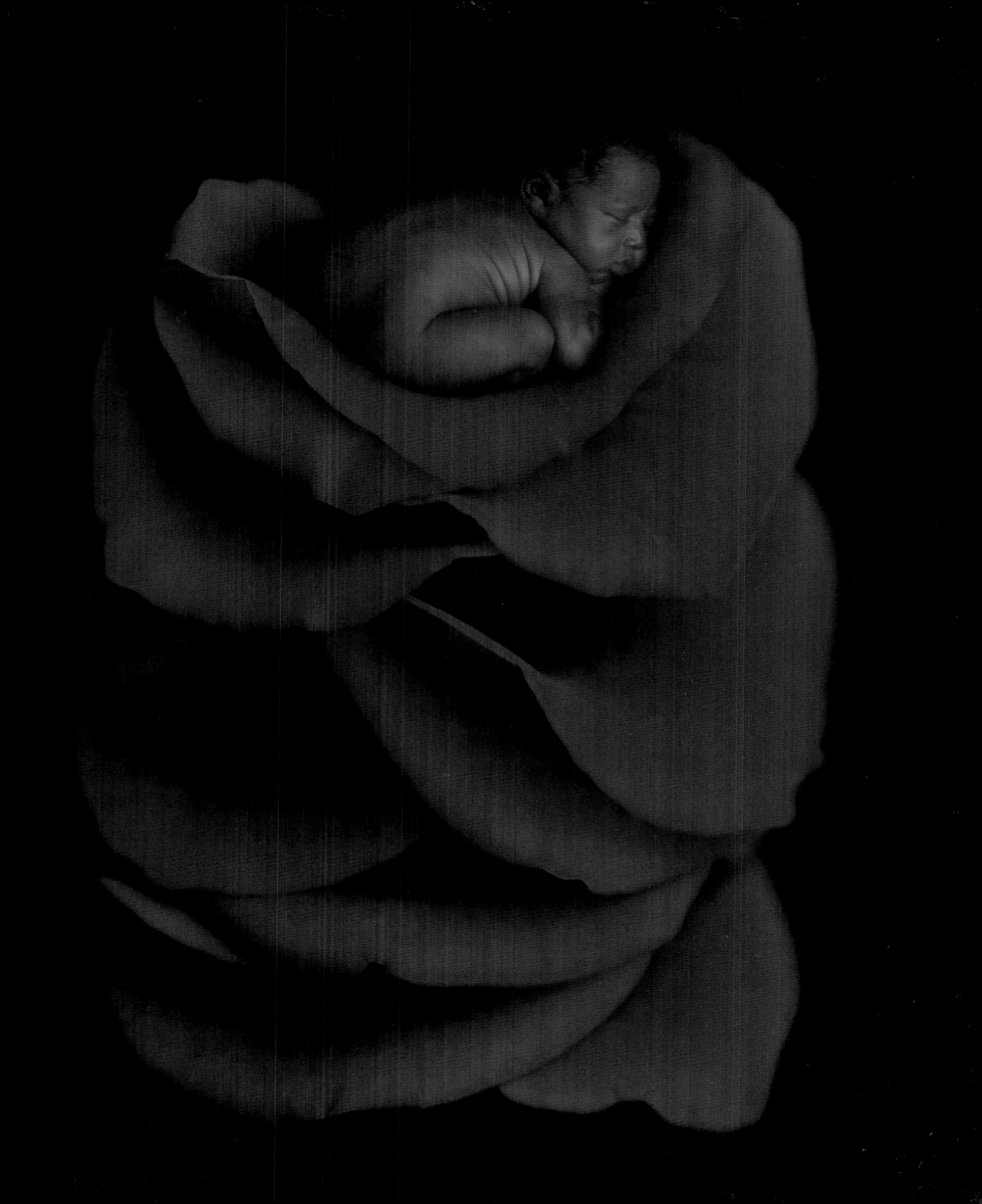

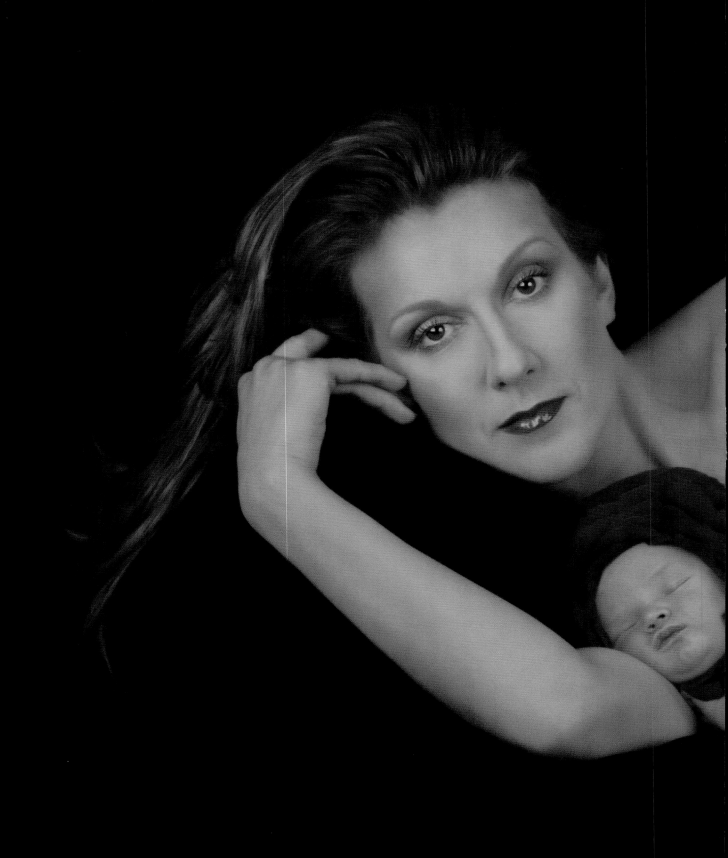

the colors of the rainbow

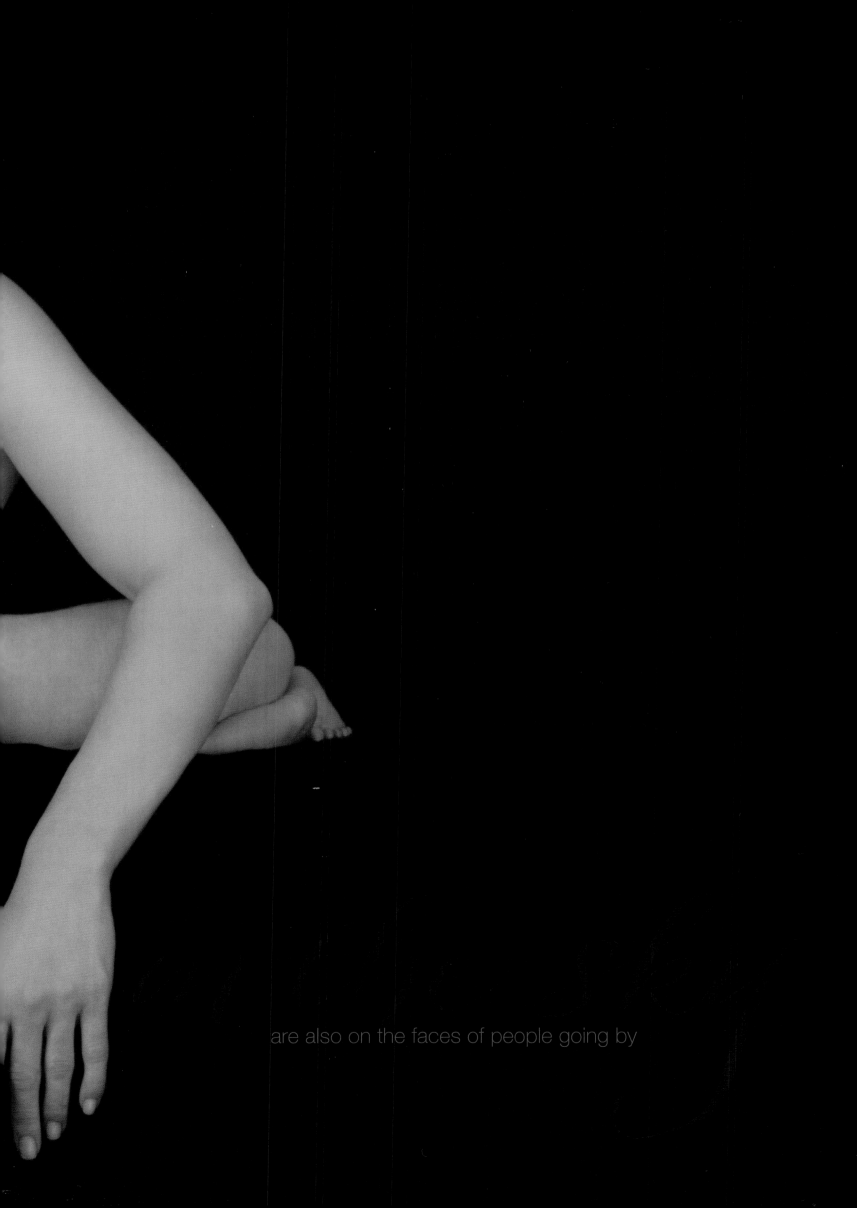

are also on the faces of people going by

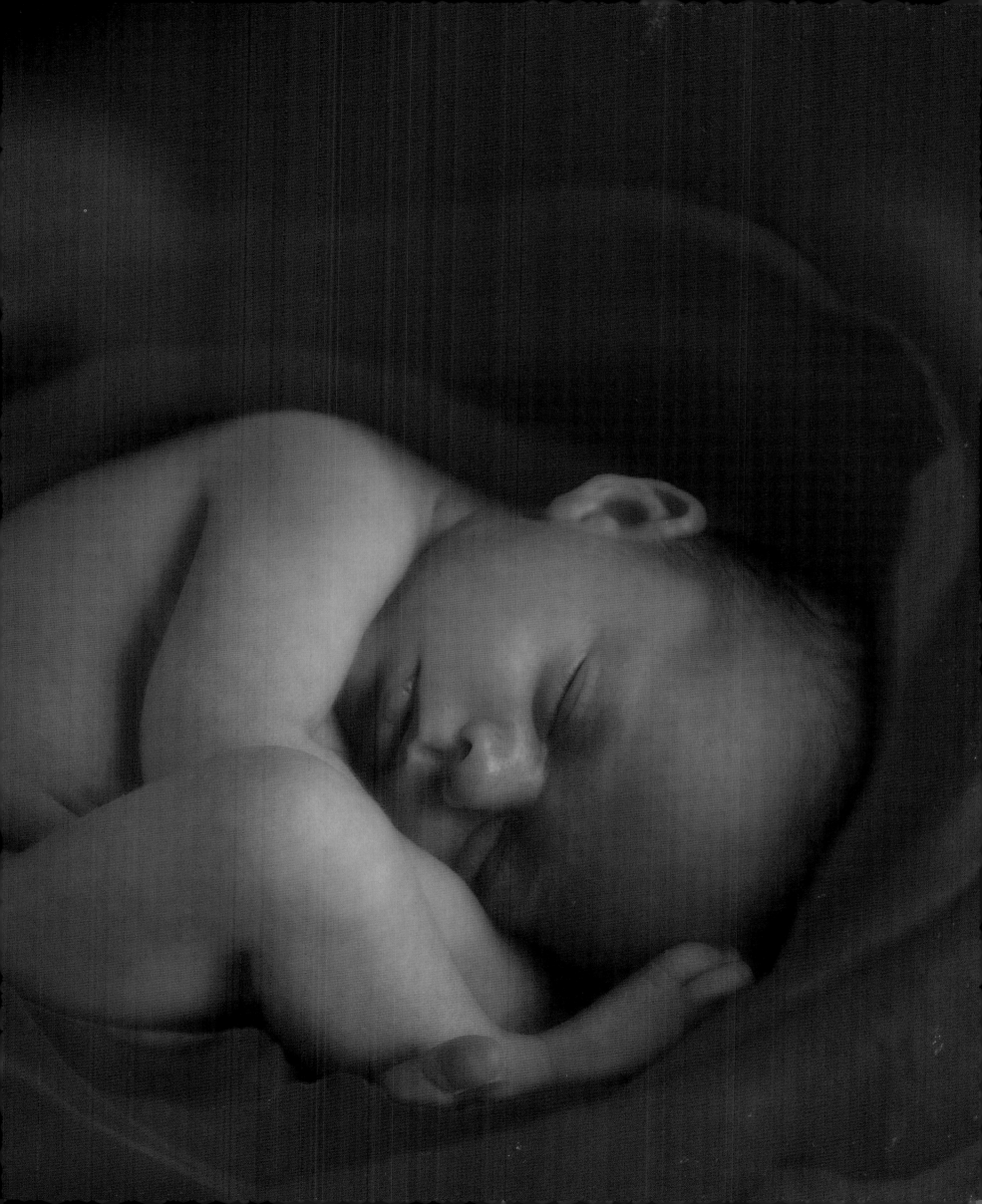

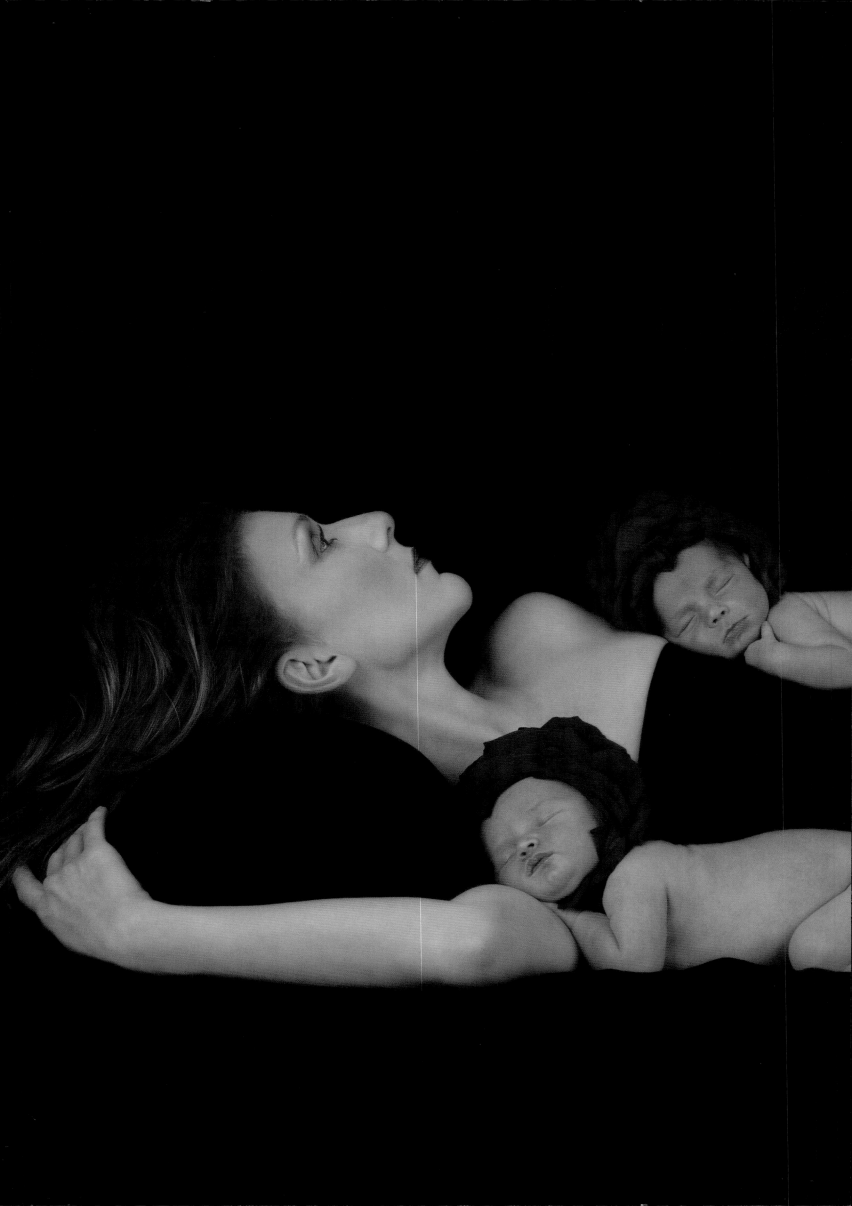

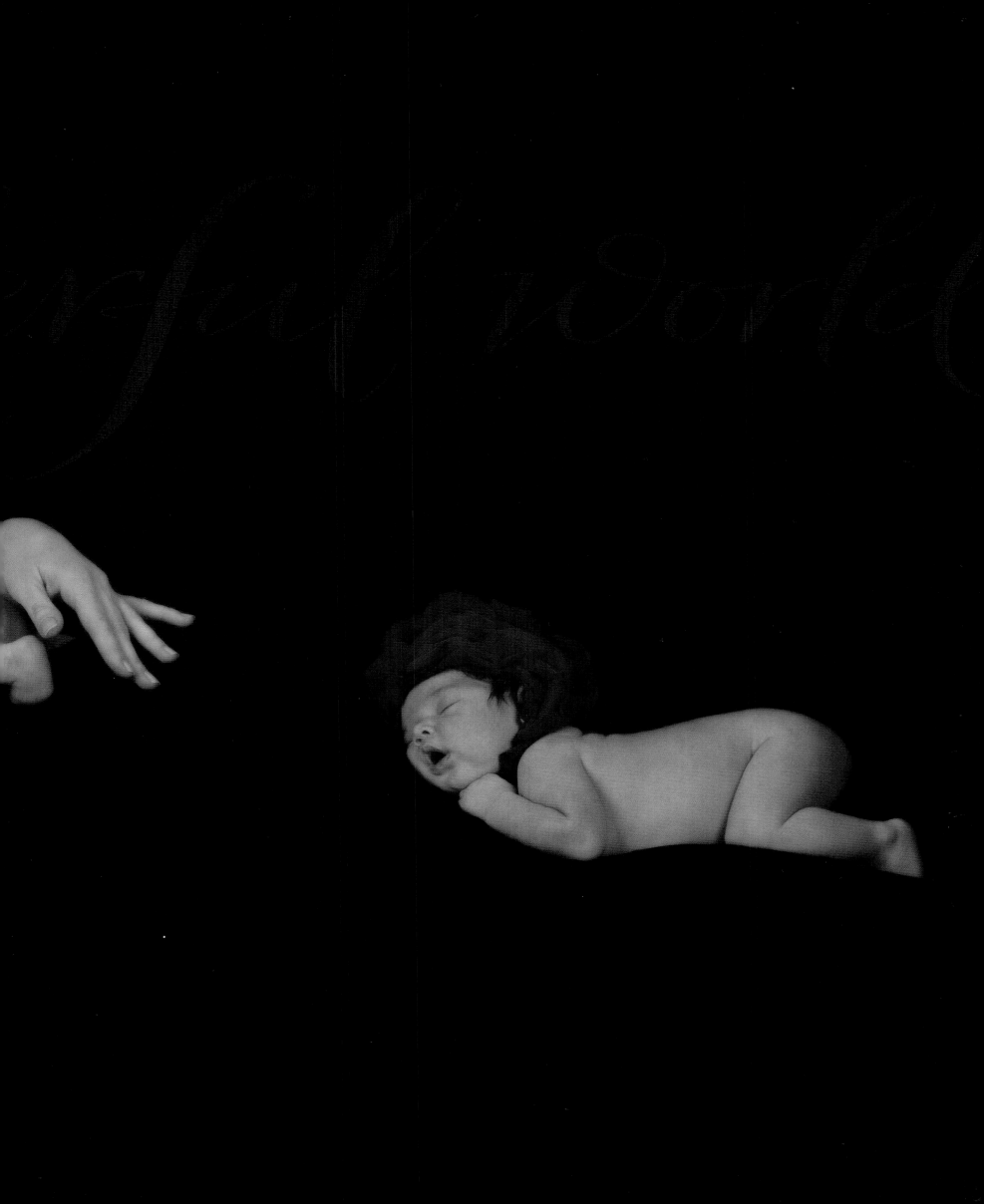

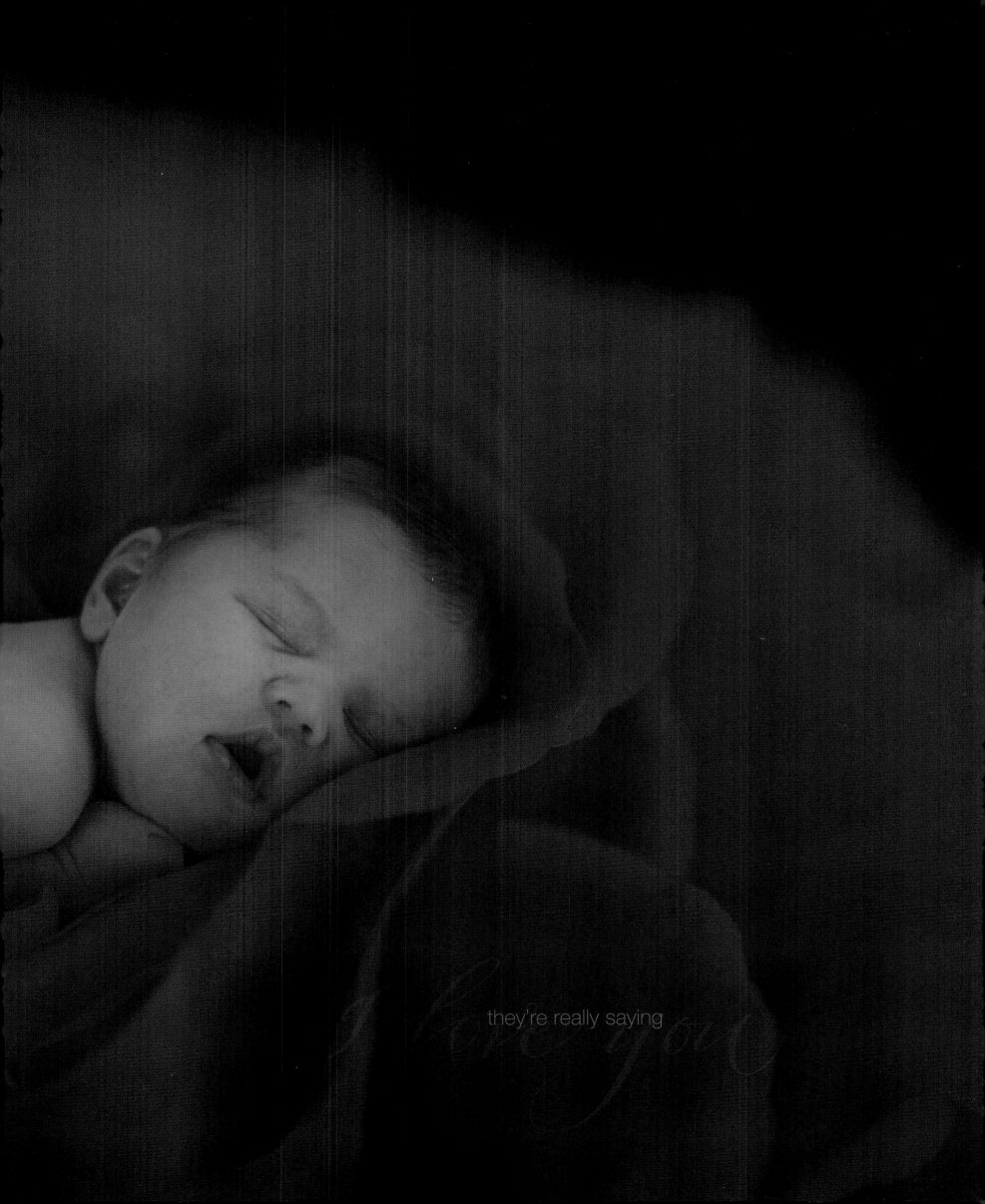

they're really saying

I hear babies crying

I watch them grow

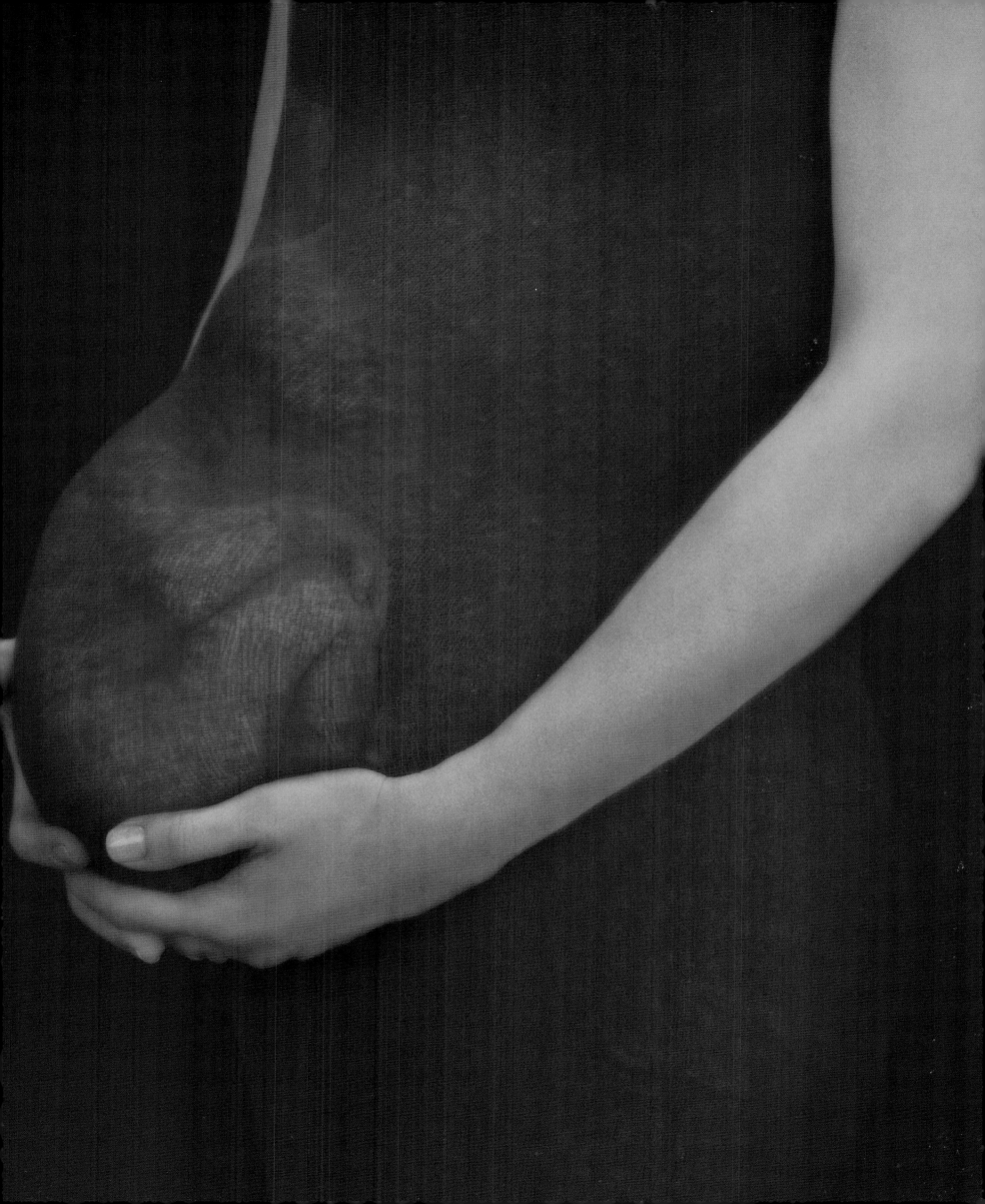

they'll learn much more

than I'll ever know

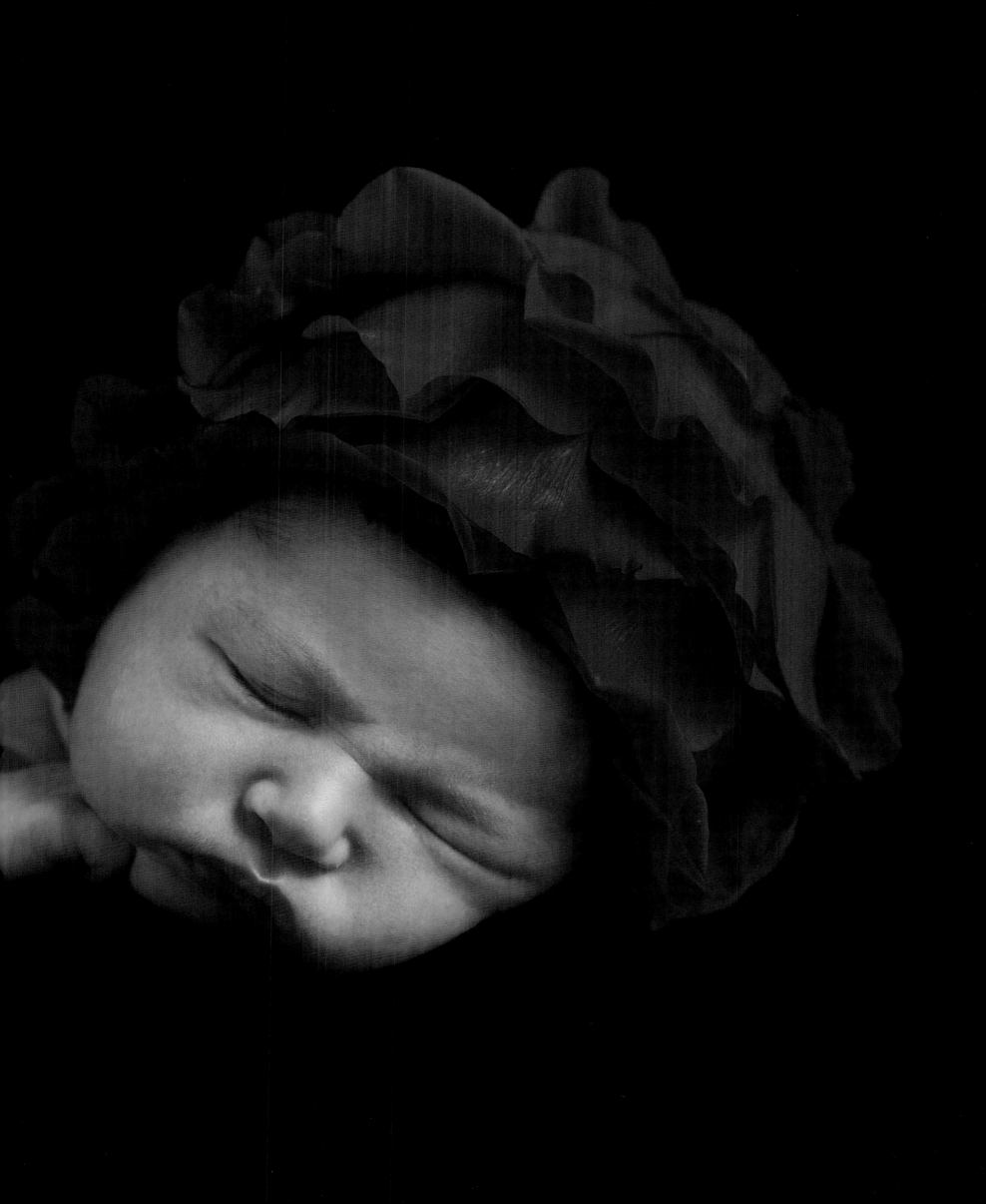

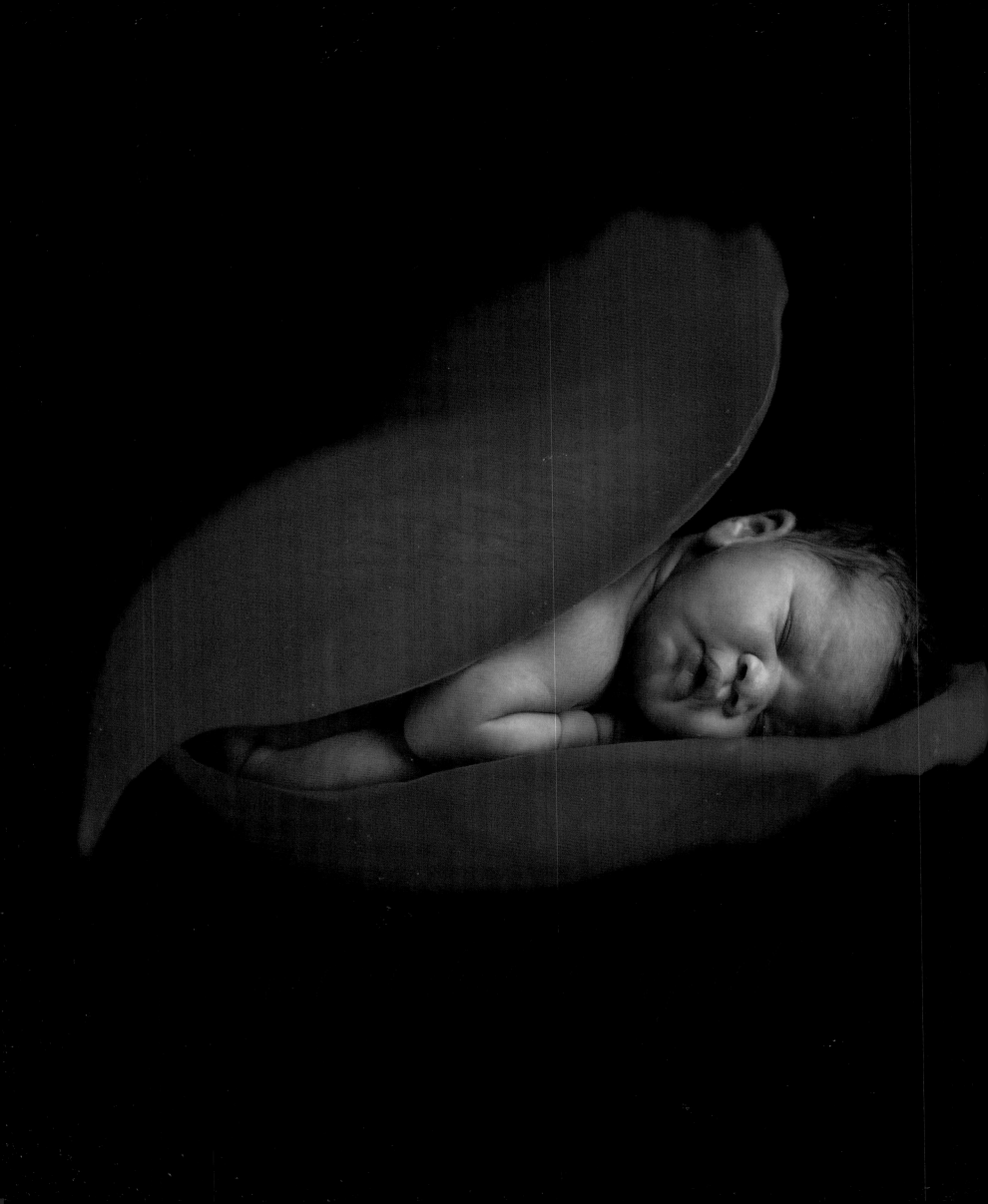

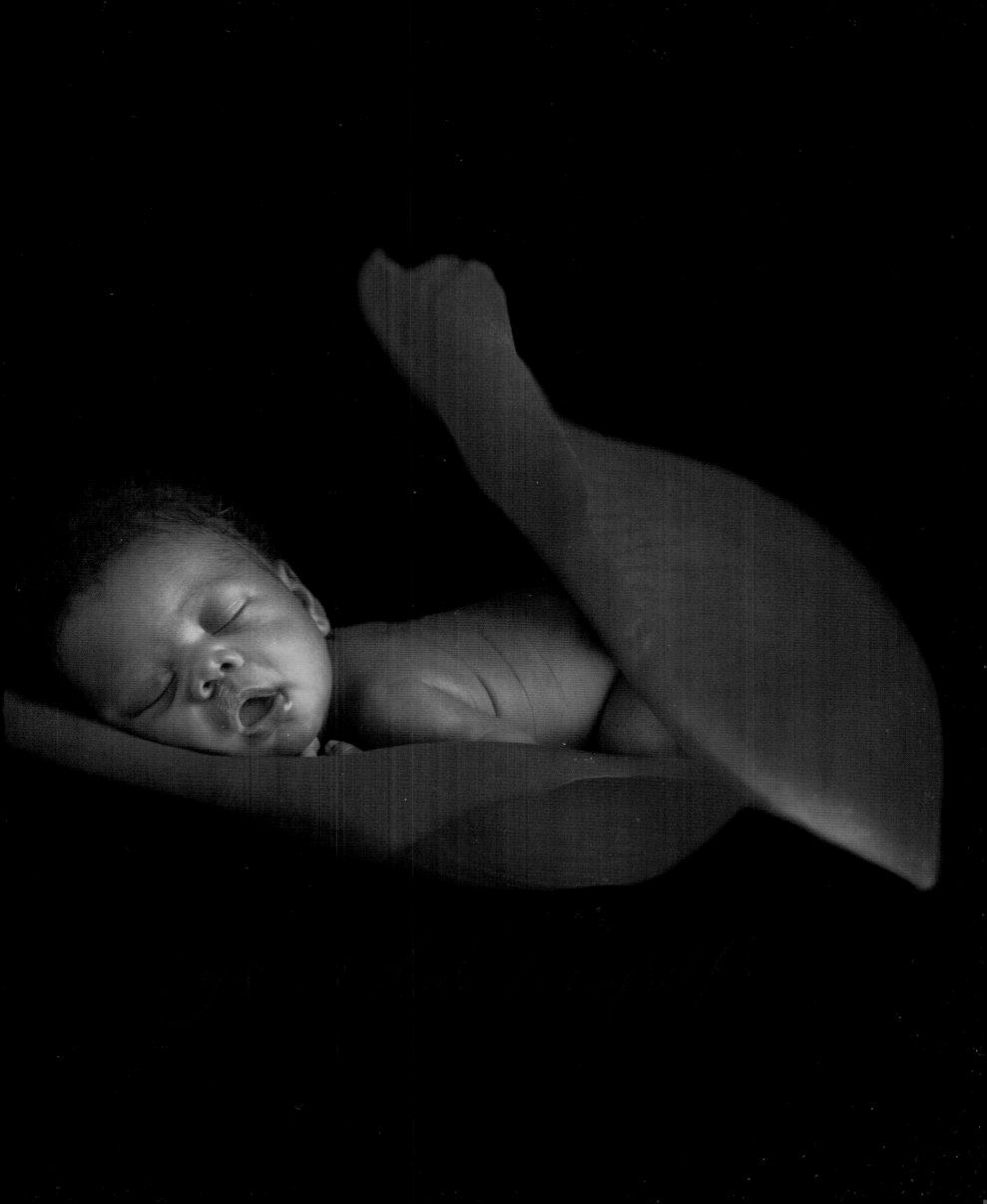

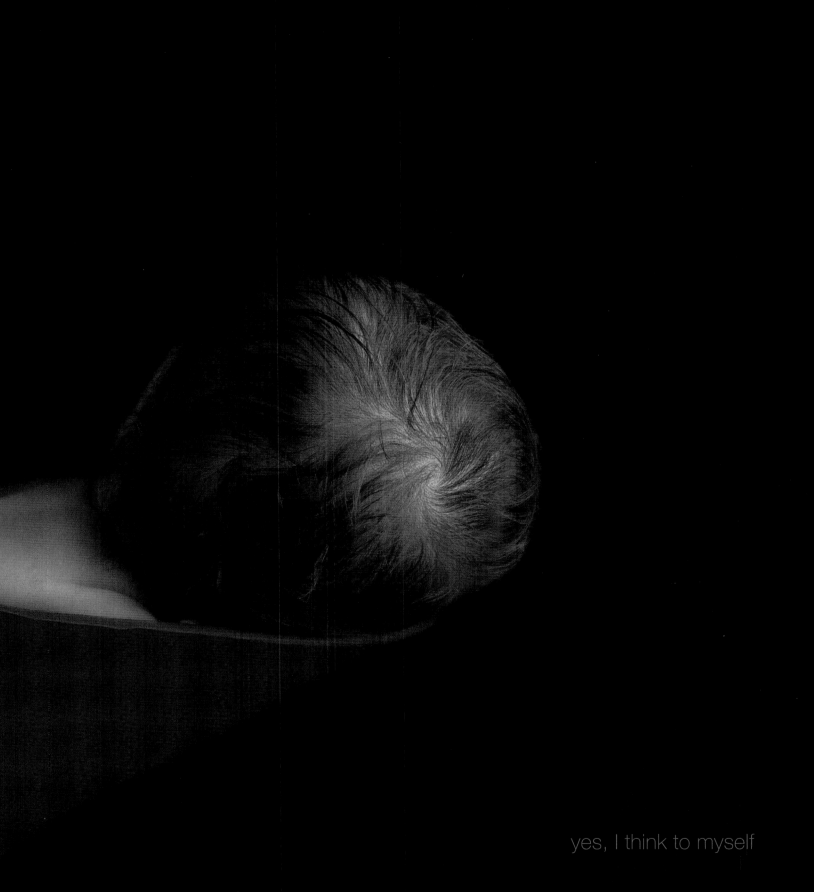

yes, I think to myself

what a wonderful world

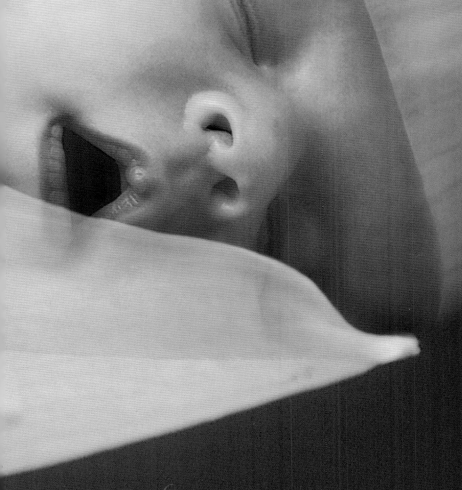

miracle

you're my life's one miracle
everything I've done that's good
and you break my heart with tenderness
and I confess it's true
I never knew a love like this 'til you

you're the reason I was born
now I finally know for sure
and I'm overwhelmed with happiness
so blessed to hold you close
the one that I love most
though the future has so much for you in store
who could ever love you more?

the nearest thing to heaven
you're my angel from above
only God creates such perfect love

when you smile at me, I cry
and to save your life I'd die
with a romance that is pure in heart
you are my dearest part
whatever it requires
I live for your desires
forget my own, your needs will come before
who could ever love you more?

there is nothing you could ever do
to make me stop loving you
and every breath I take
is always for your sake
you sleep inside my dreams and know for sure
who could ever love you more?

you're my life's *one miracle*

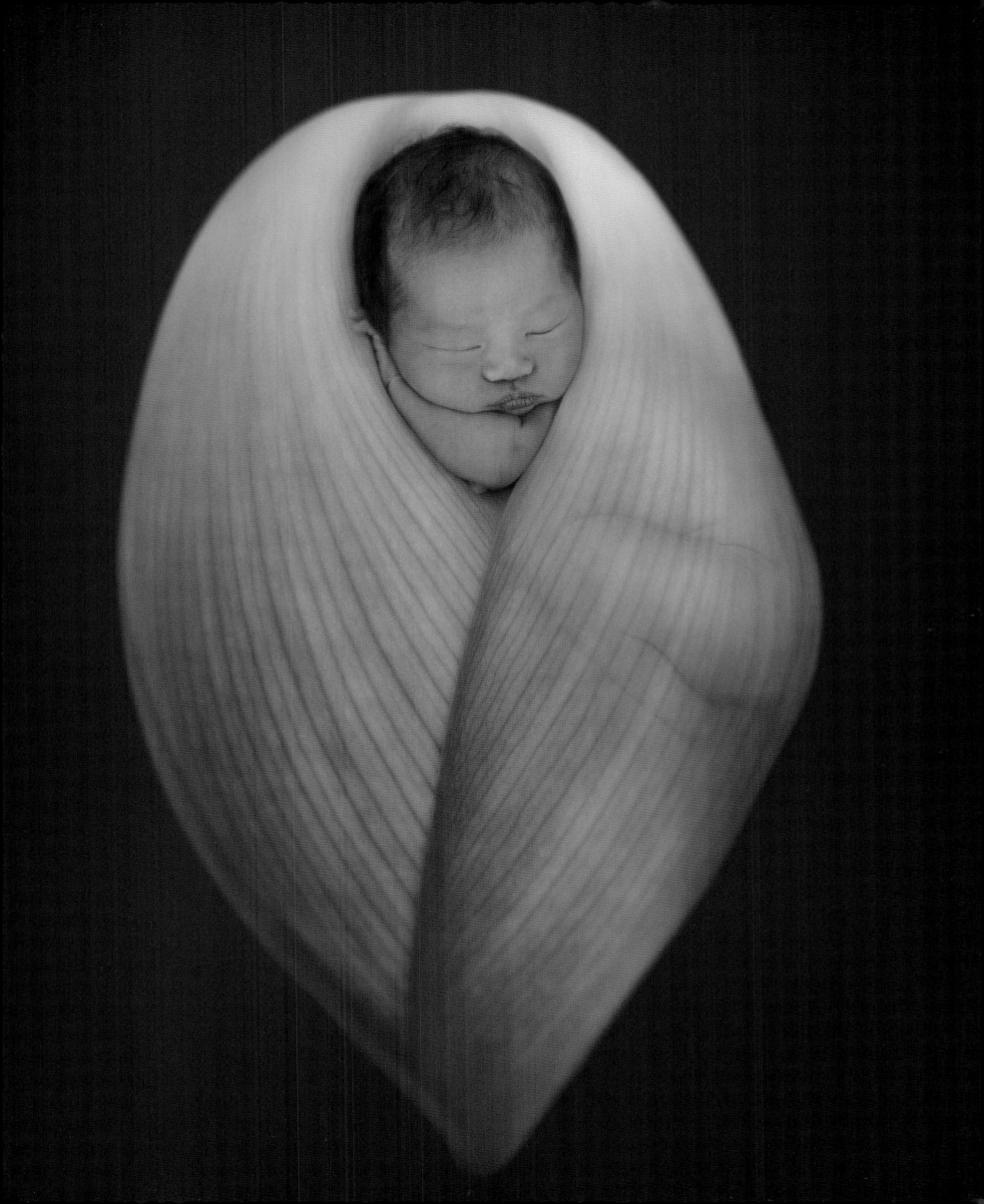

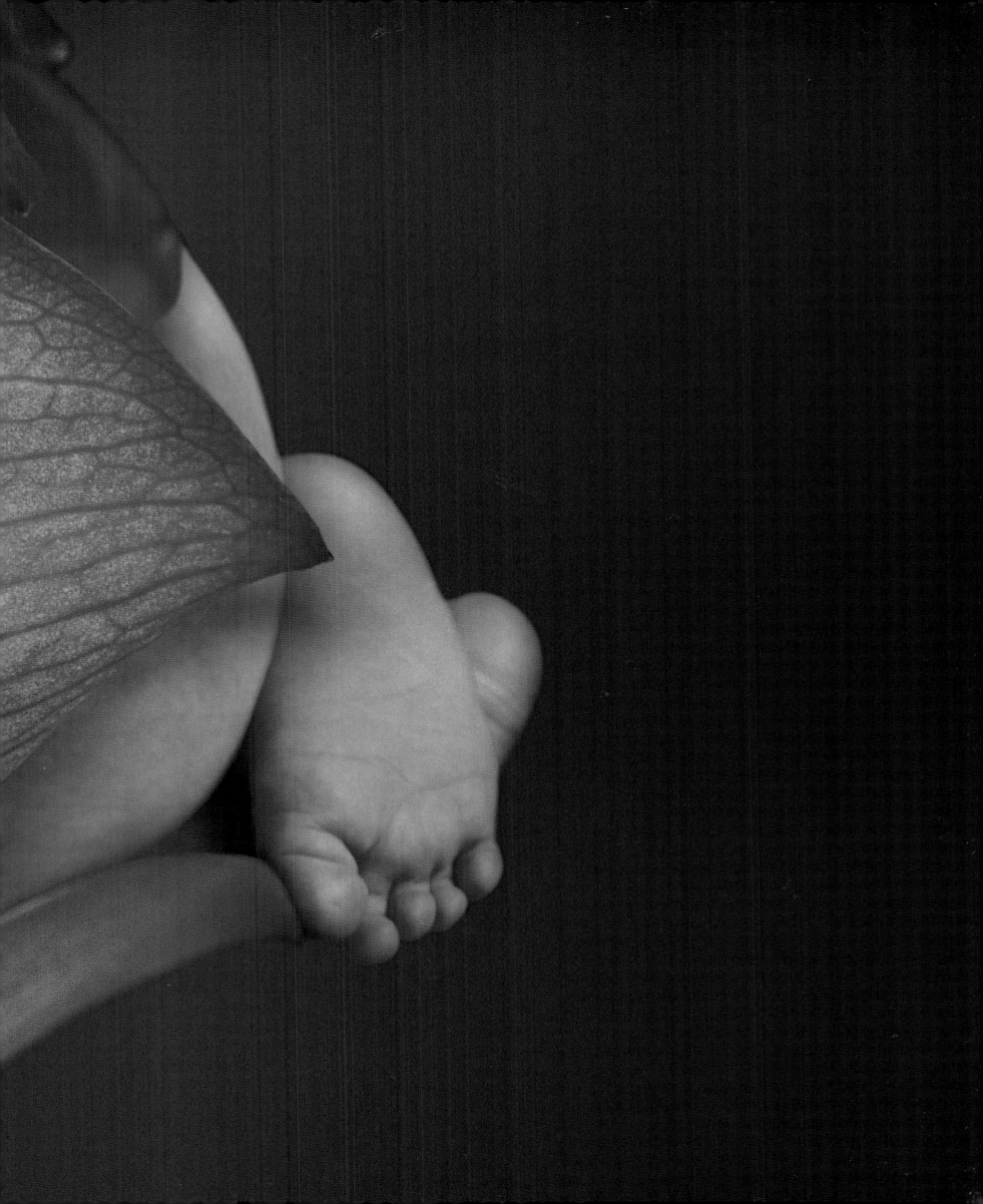

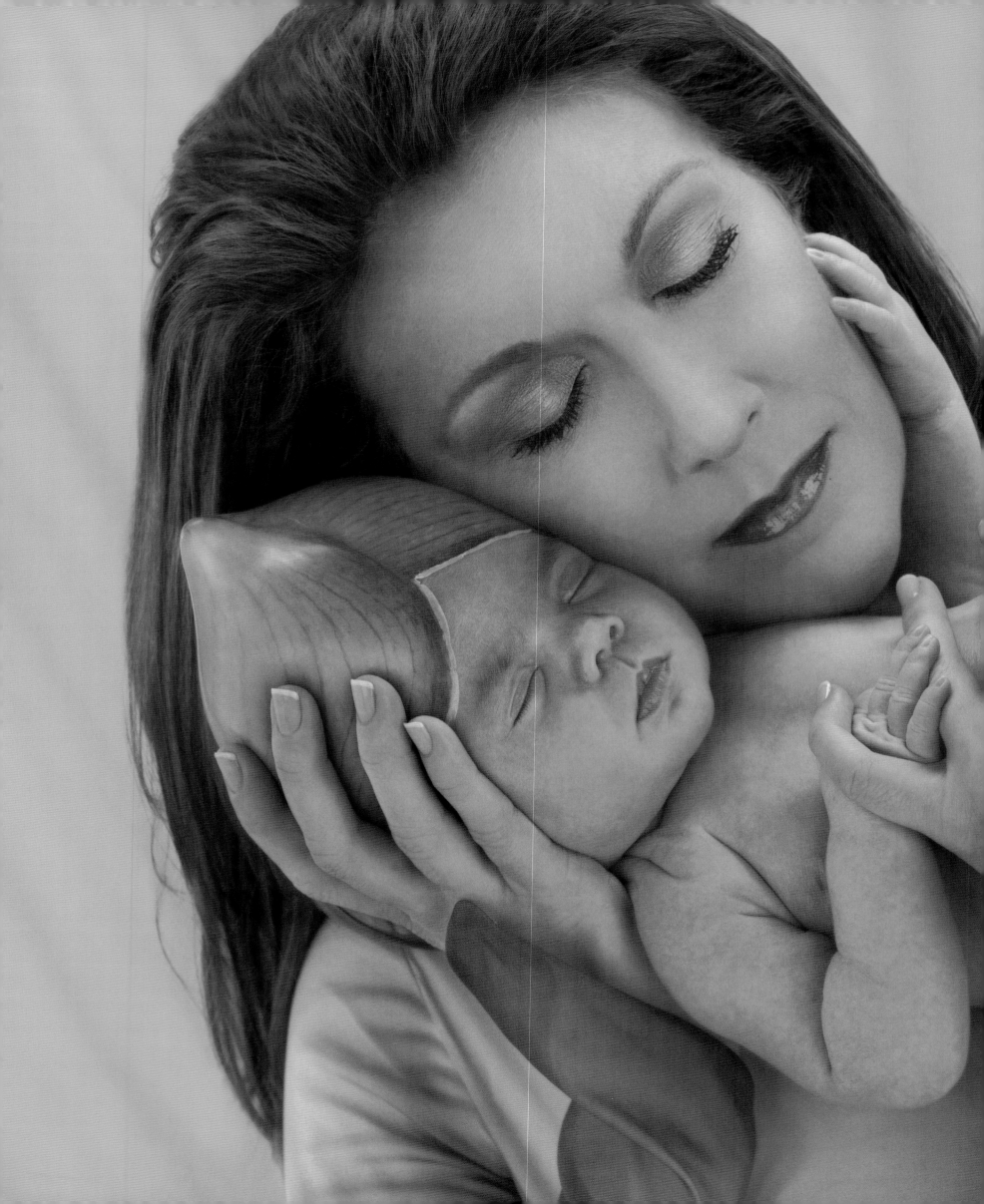

you're the
reason I was born

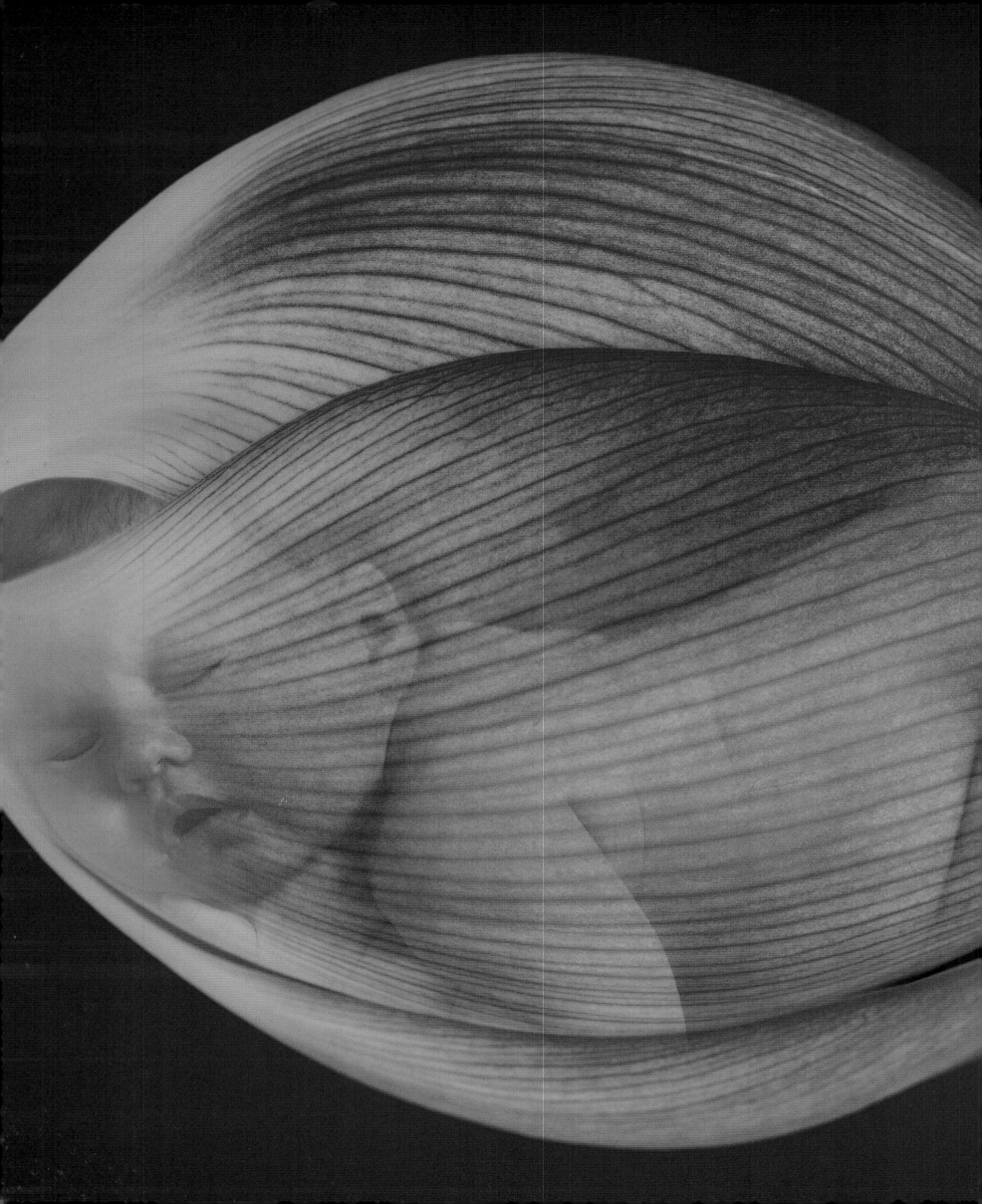

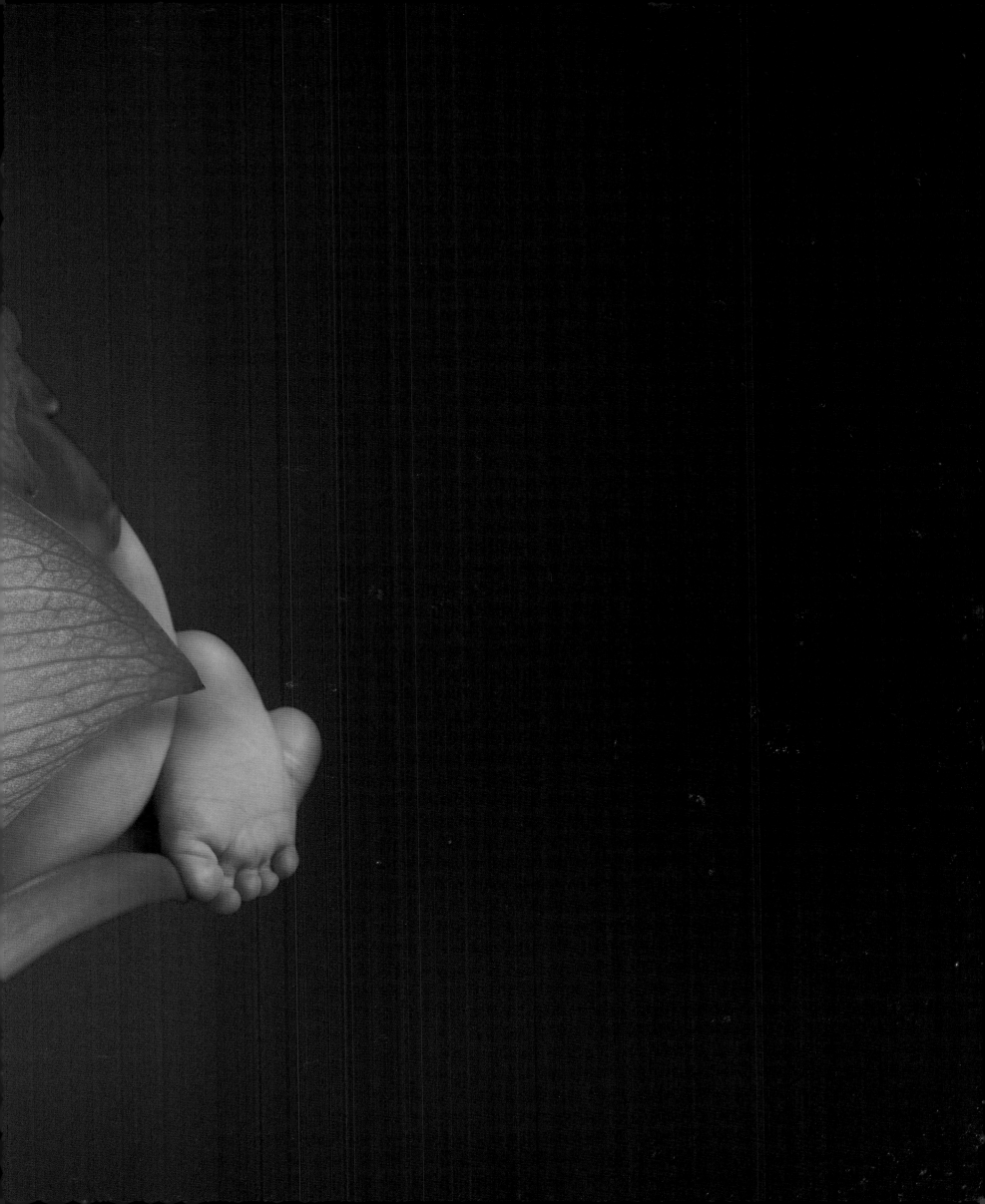

so blessed to hold you close

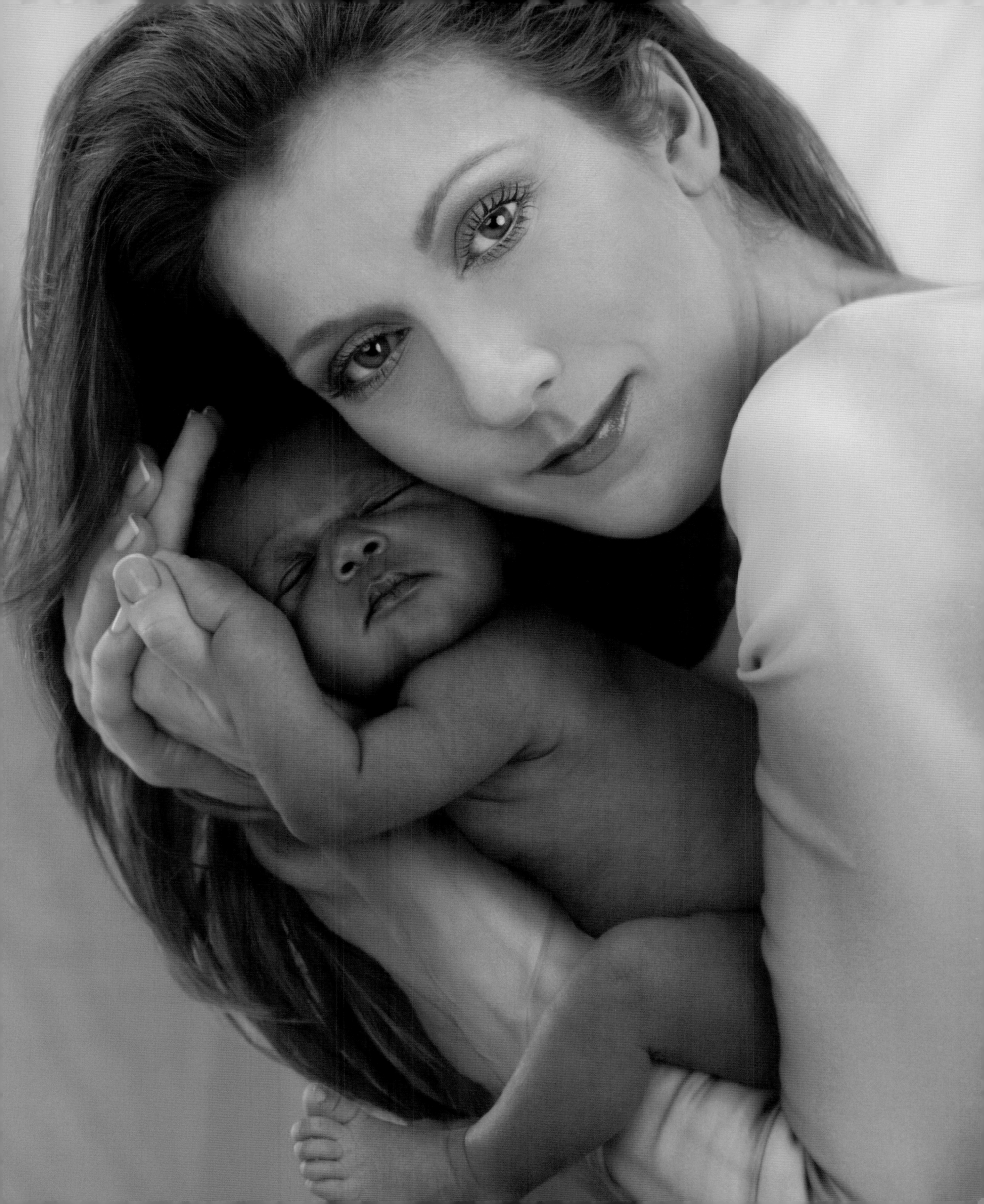

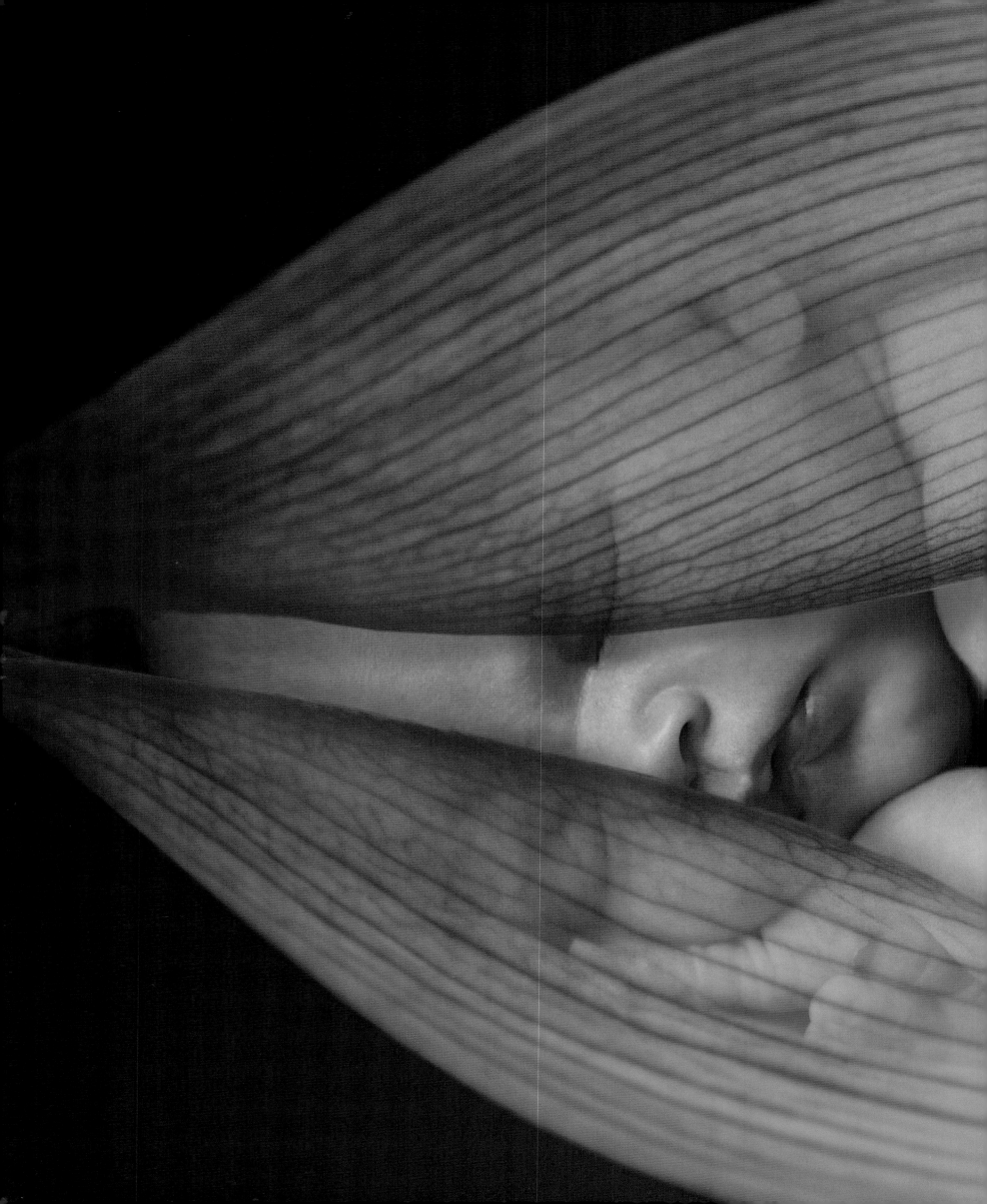

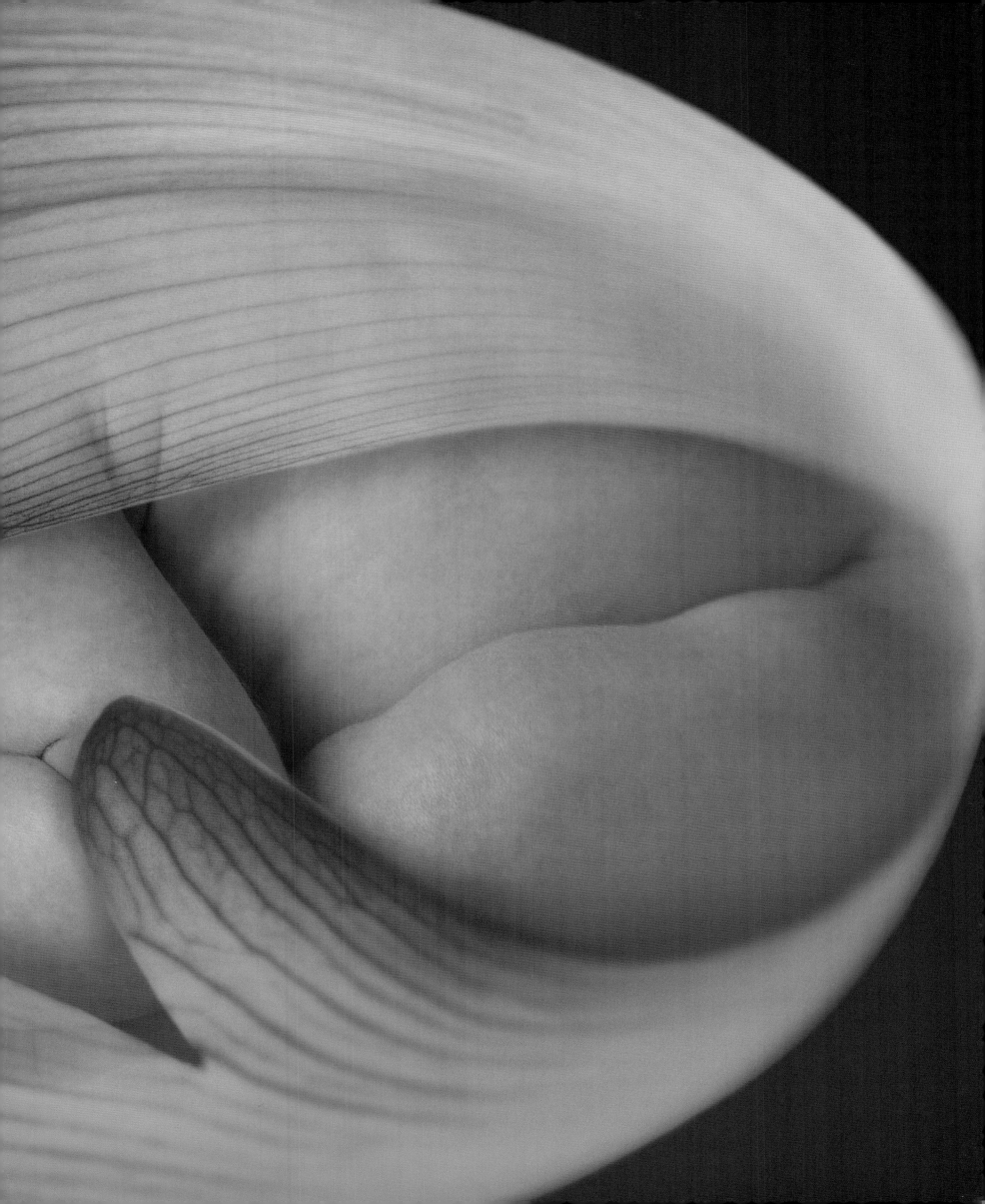

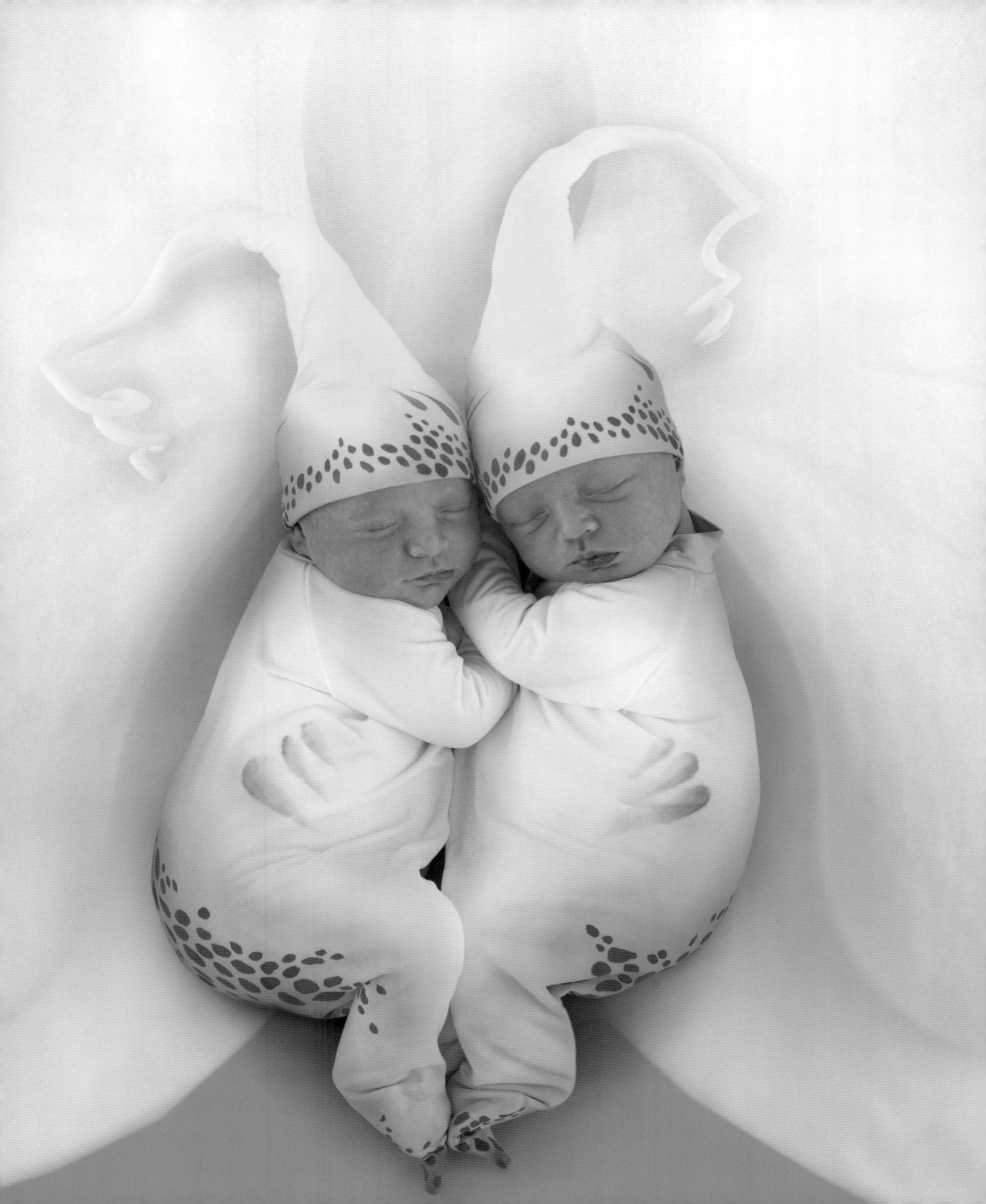

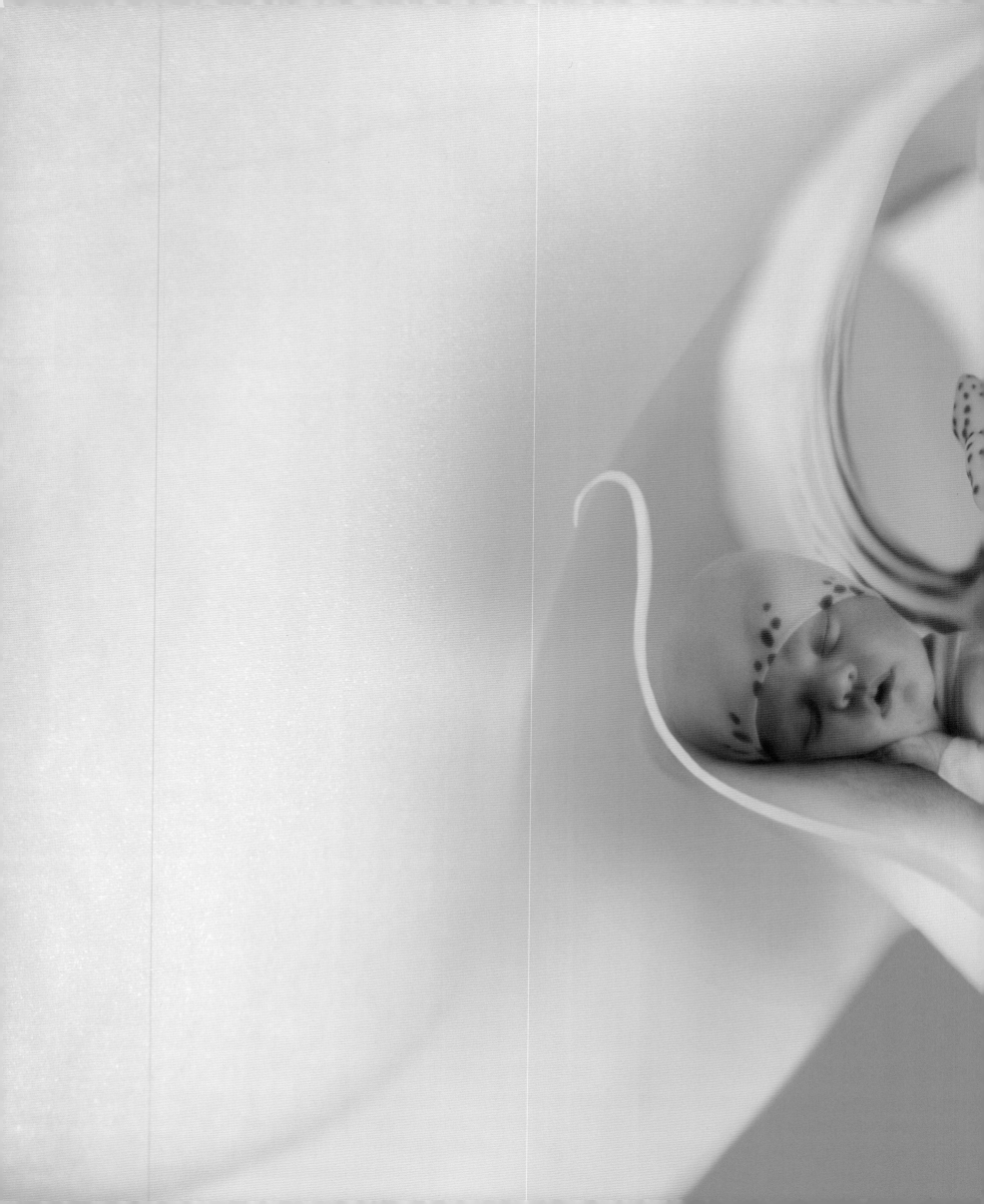

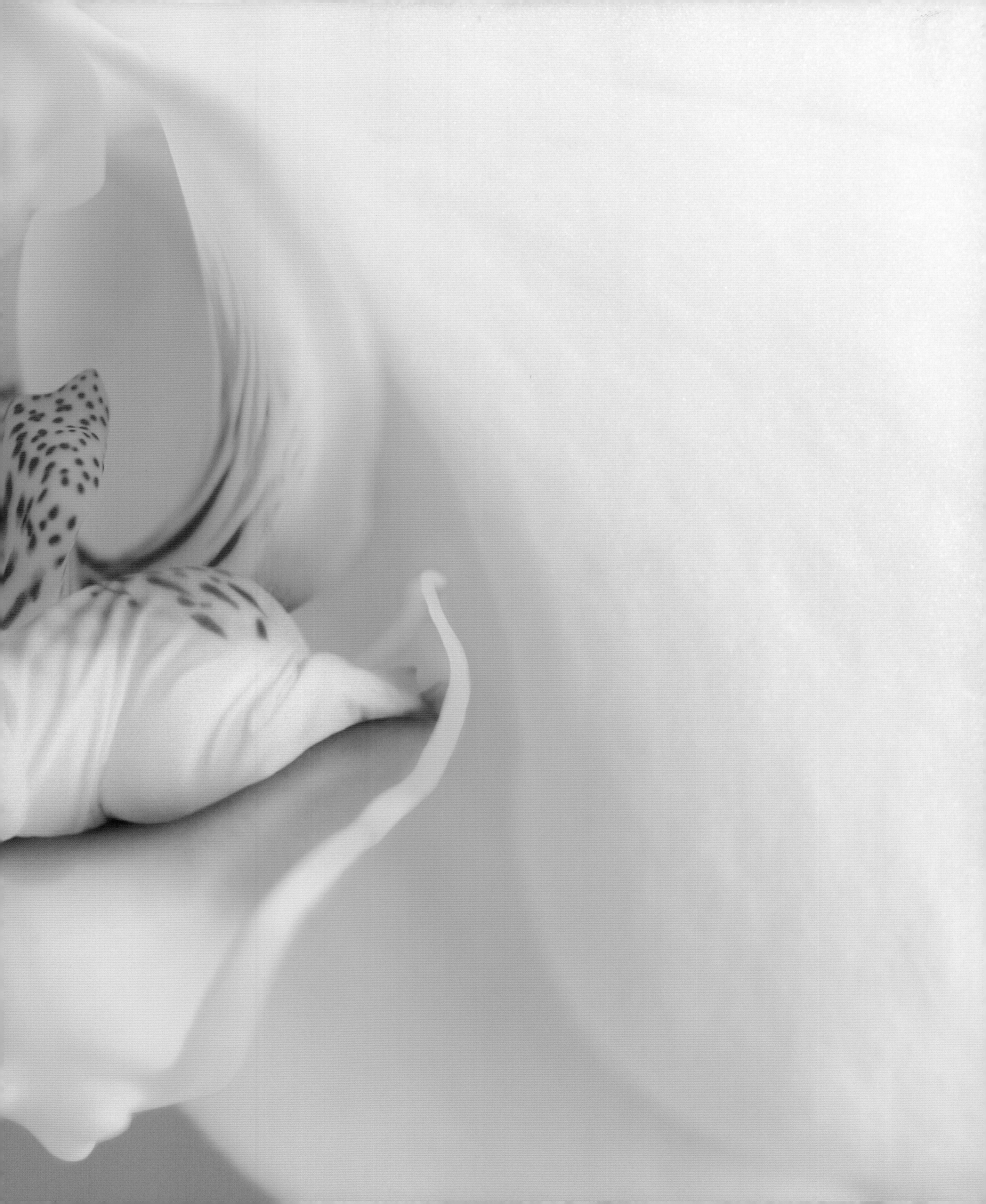

you were born to fly

so fly

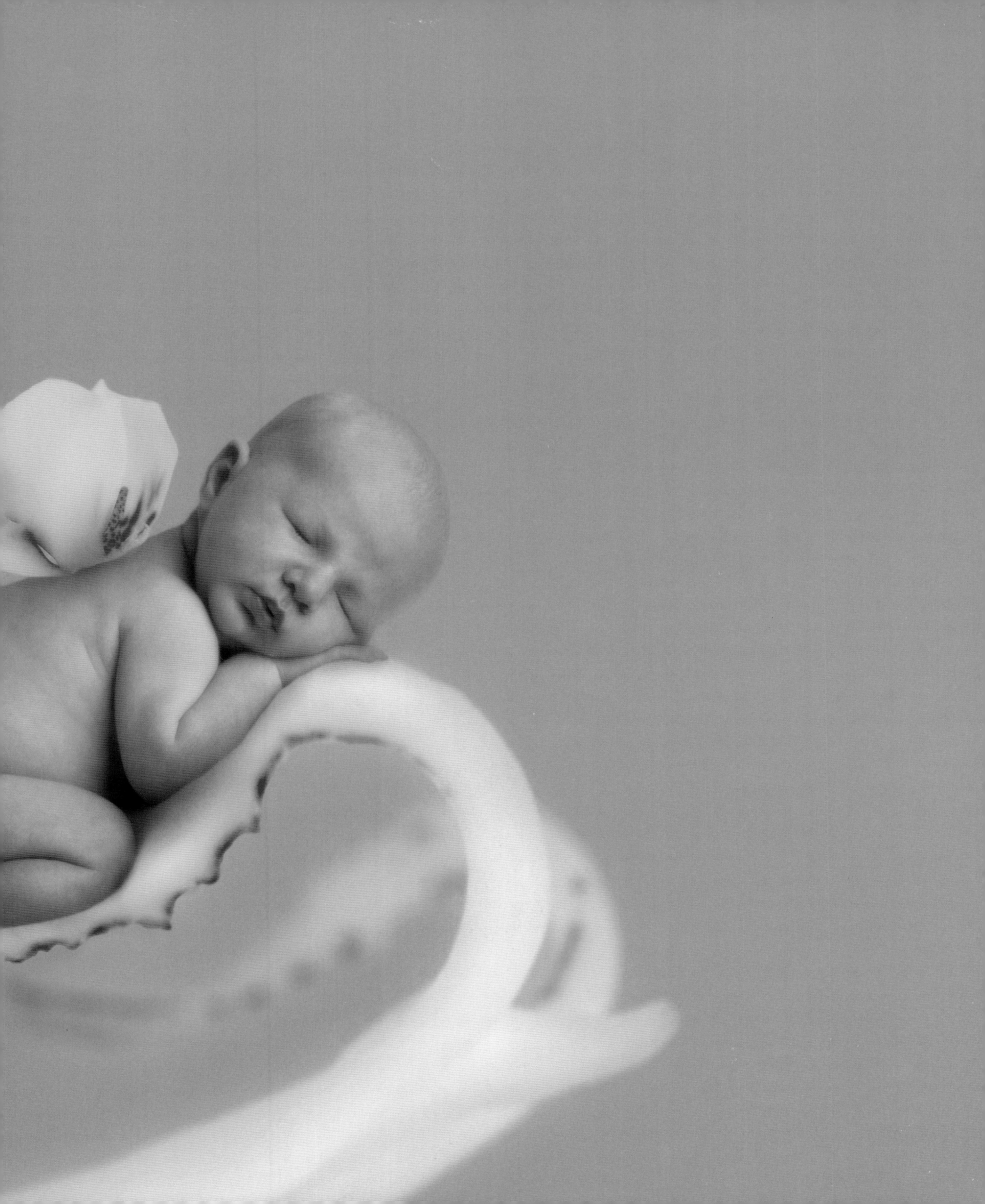

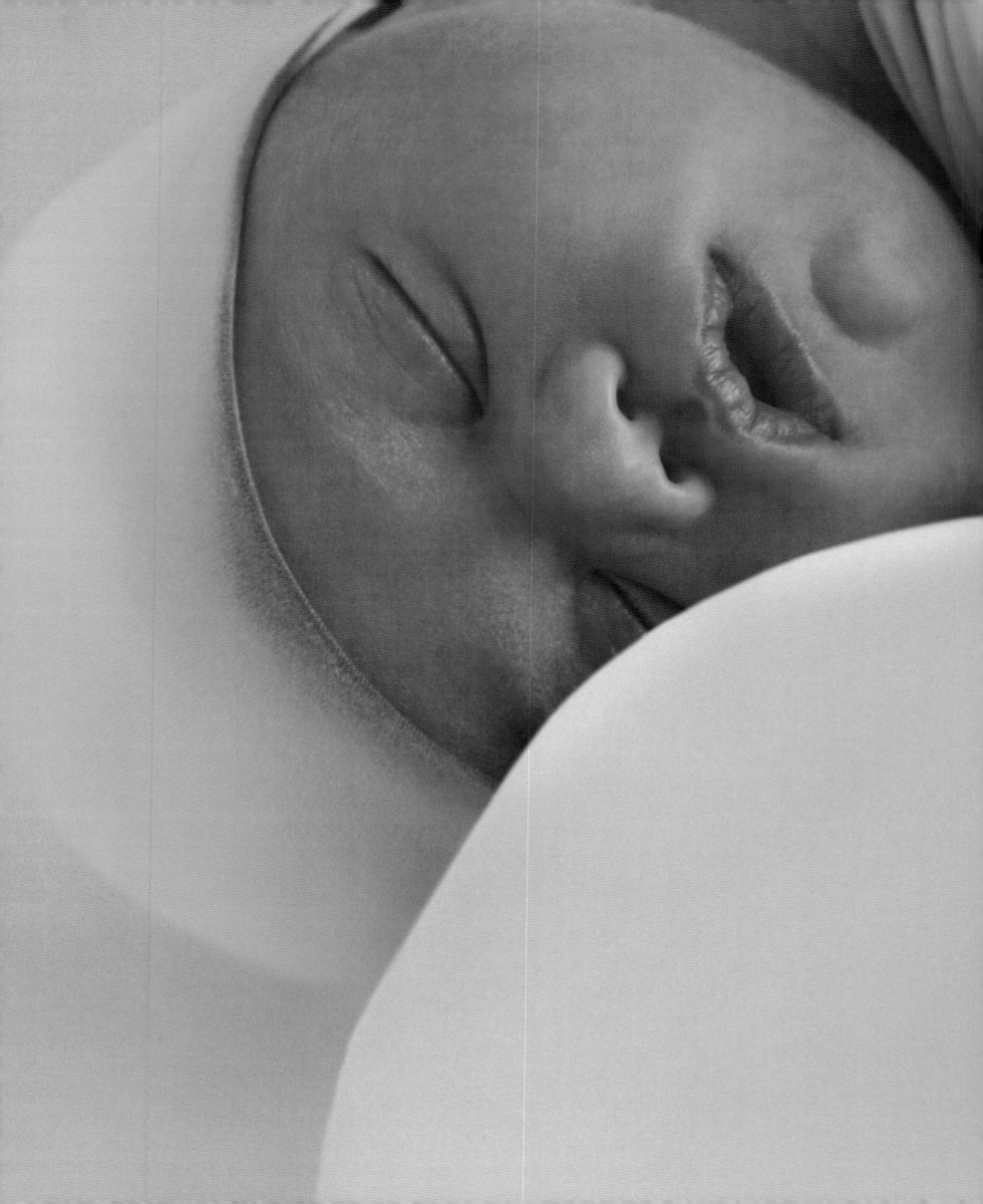

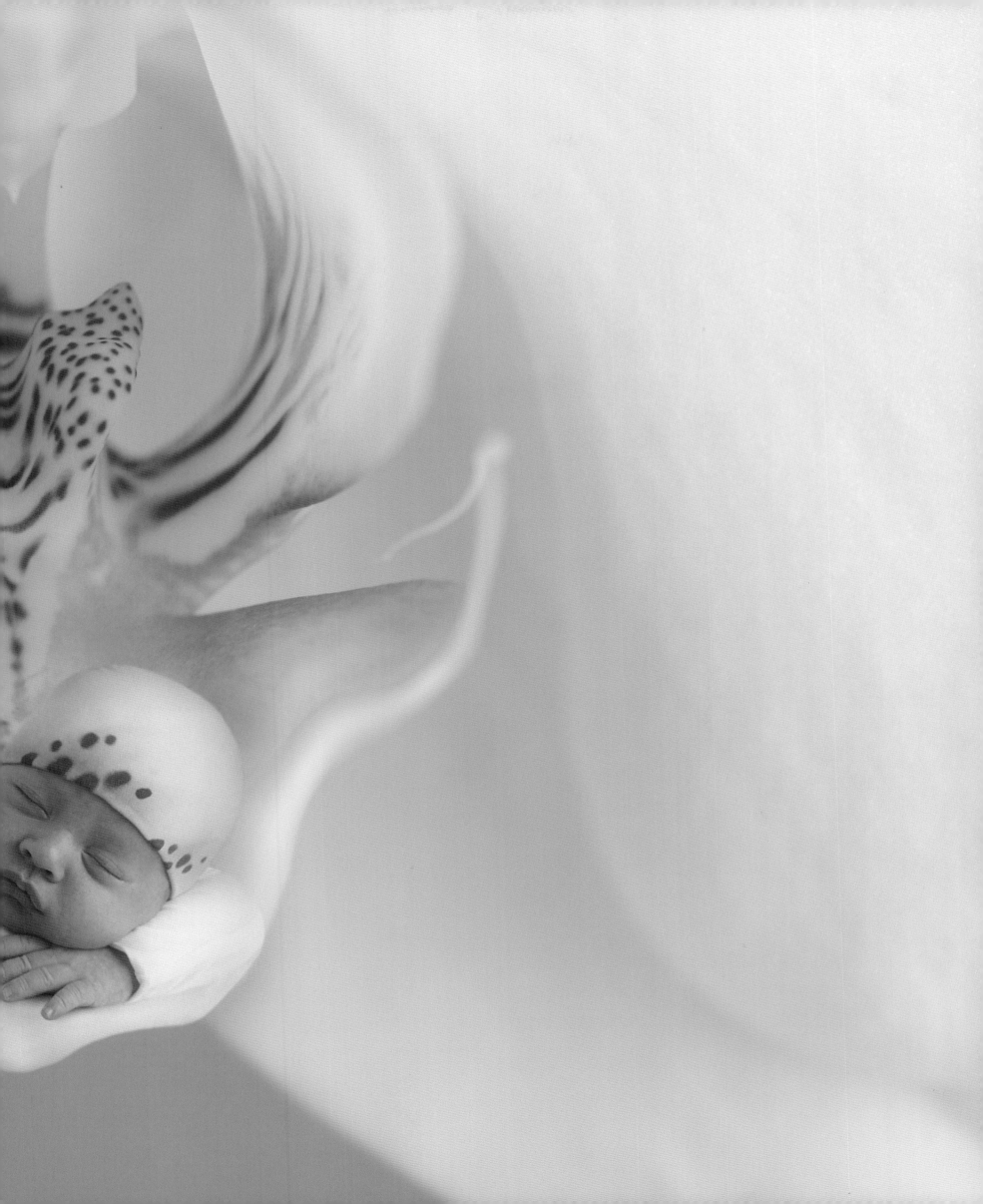

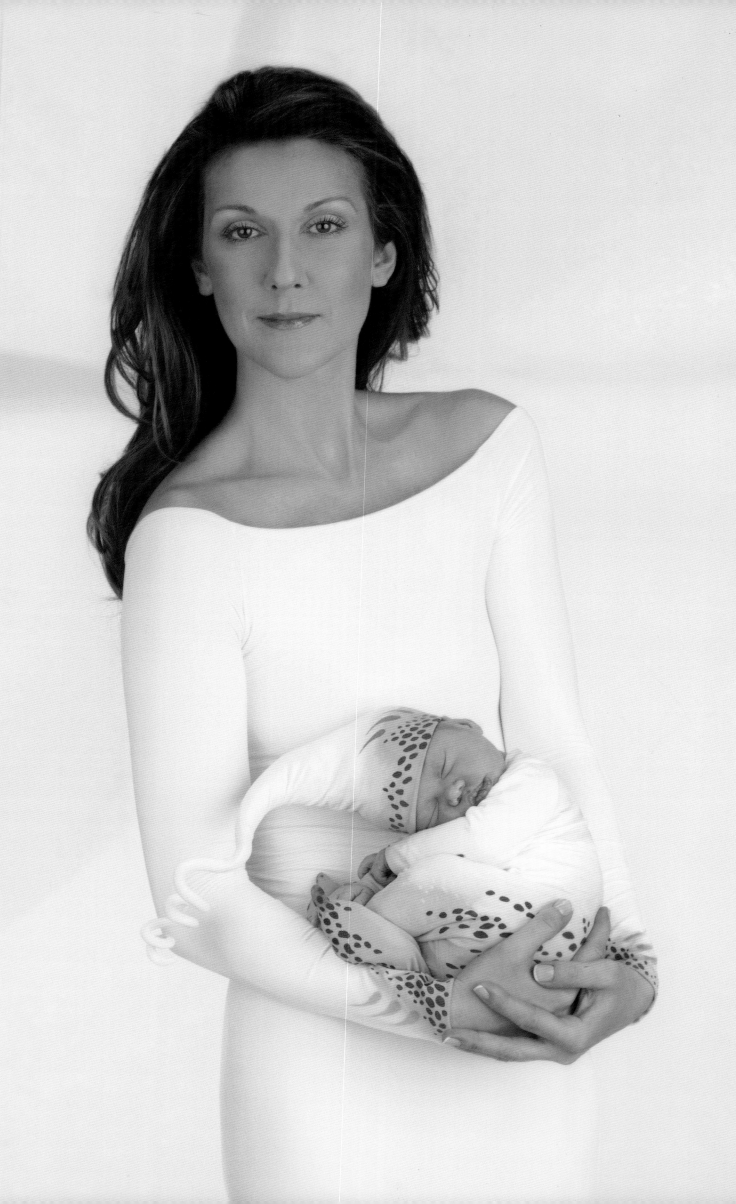

let my heart be your beacon

home

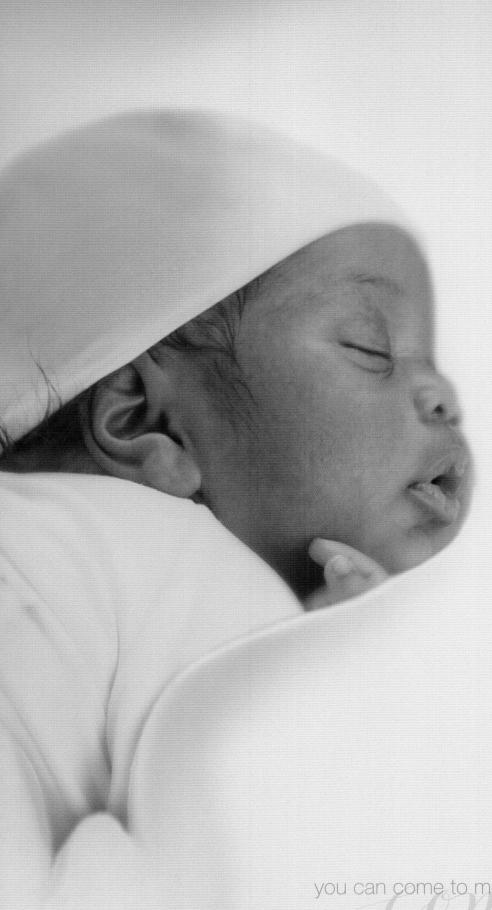

you can come to me *come to me*

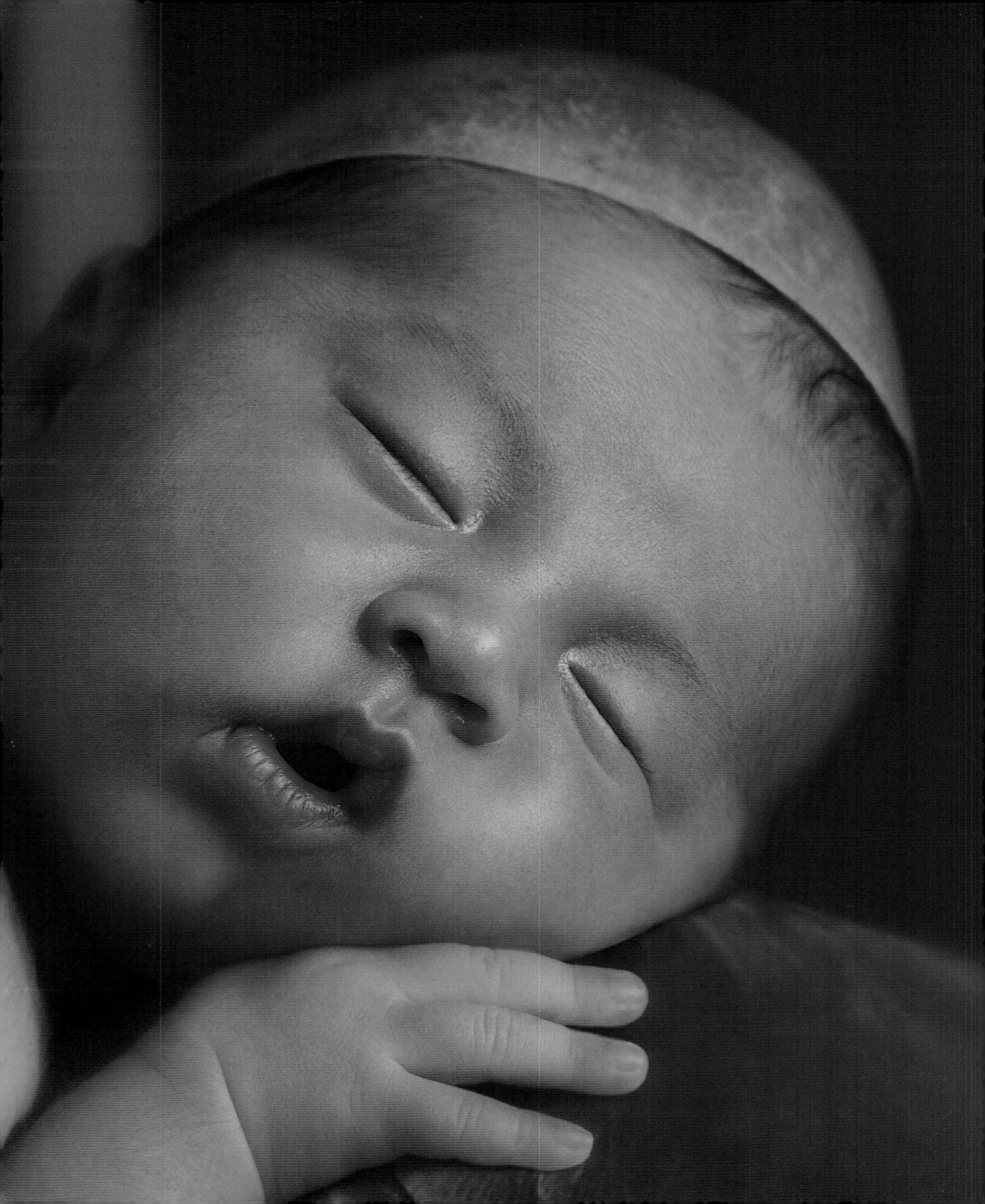

sleep tight

now hush
my little one
don't be afraid
your daddy's right here

it's just
a little dream
and now it's gone
there's nothing to fear

so close your eyes
I'll sing a sweet lullaby
lay your head close to my heart

(chorus)
and sleep tight
the angels hover over you
they spread their wings
to keep you safe and warm
the starlight
in the heavens high above you
will light a path
to find your way back home
sleep tight

and now
my sleepy head
your carriage waits
to take you off to bed

let go
your tiny hands
and drift away
to a bright enchanted land

I promise you
your sweetest dreams will come true
now leave this weary world behind

(chorus)

so close your eyes
and wish upon the brightest star
'cause when you dream
it doesn't matter where you are
near to me or very far
I'll always be with you

(whispered)
sleep tight
sleep tight
sleep tight

(chorus)

yeah I'll keep you safe
safe and warm

my little one don't be afraid

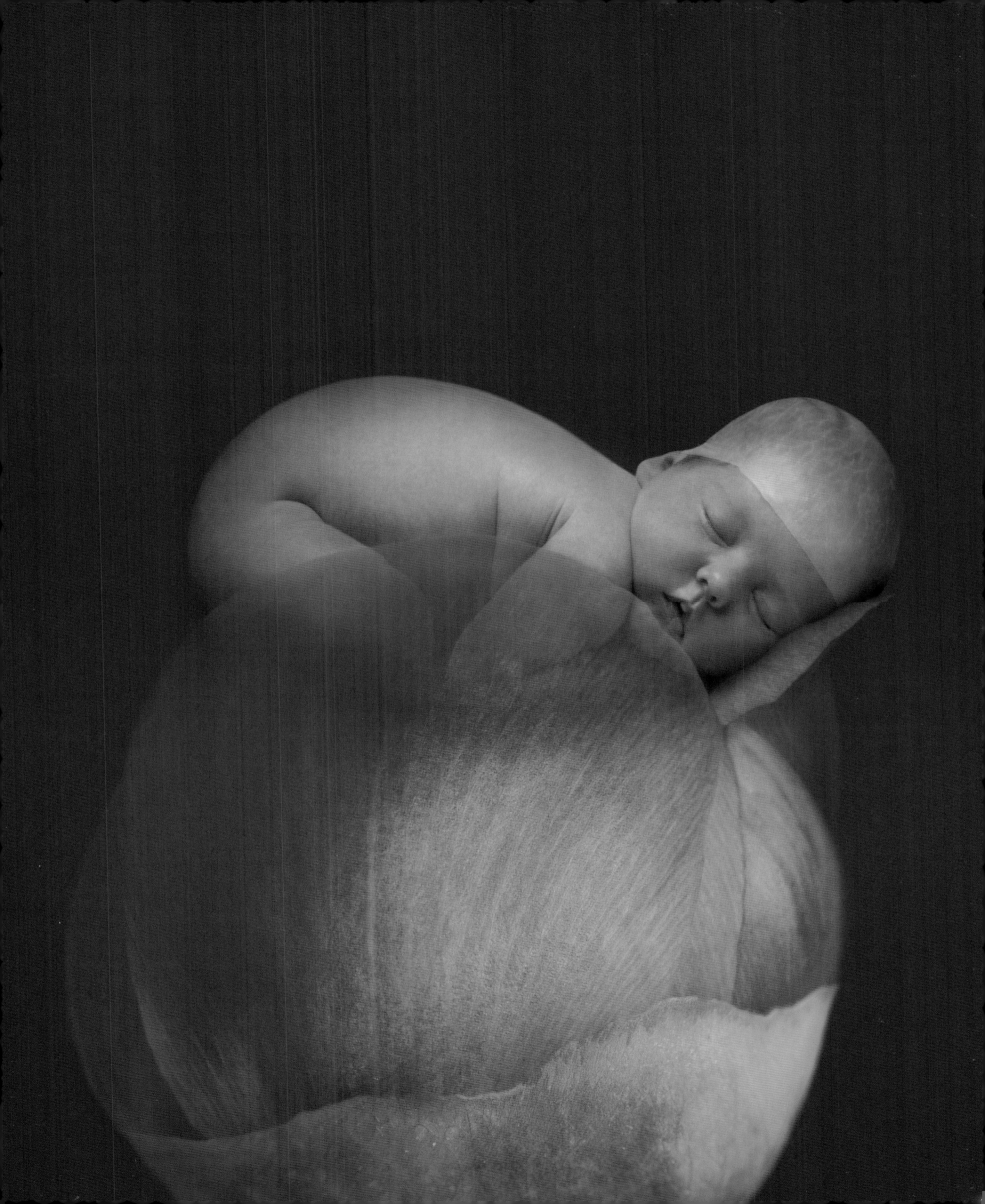

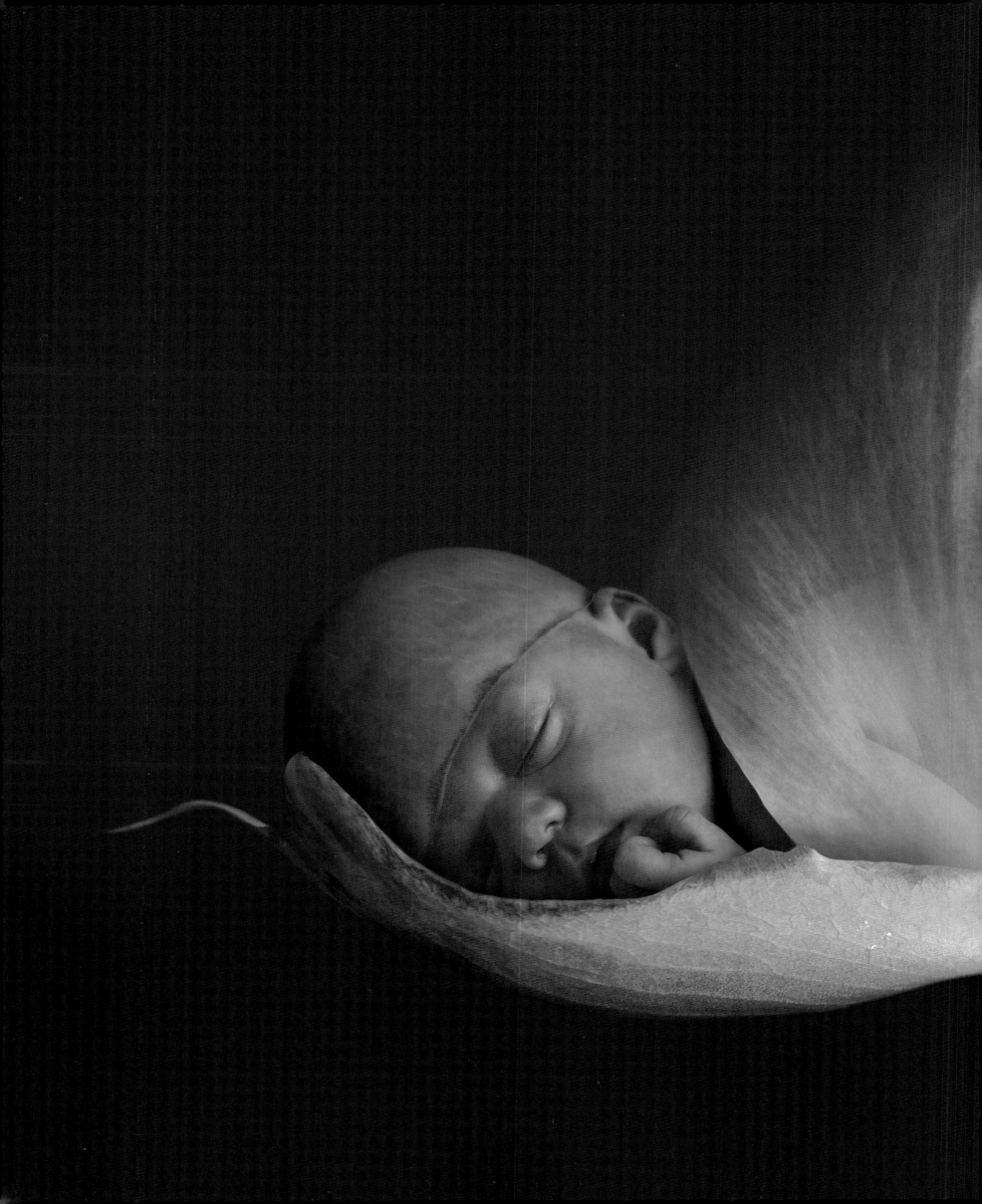

so close your eyes

I'll sing a sweet lullaby

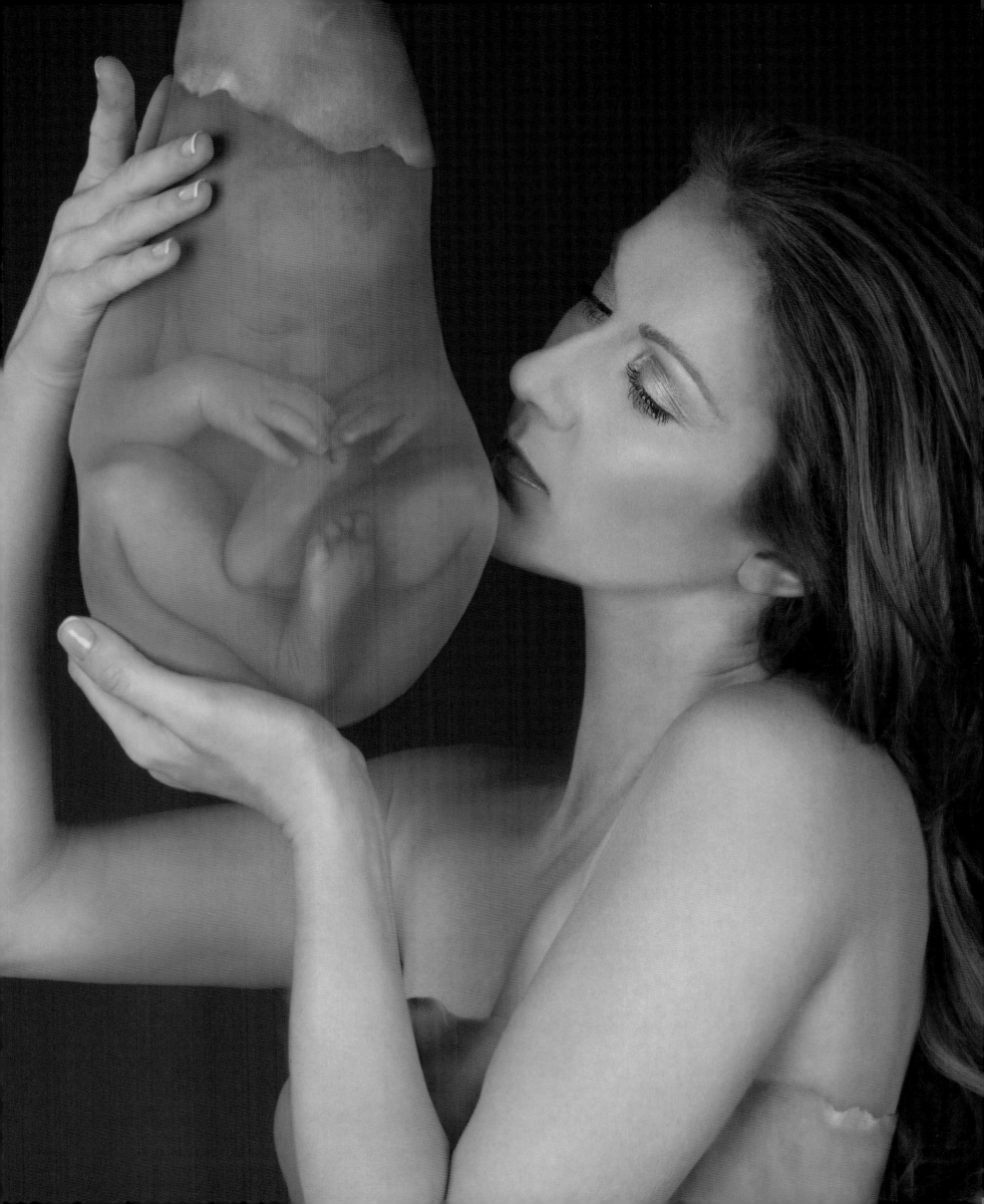

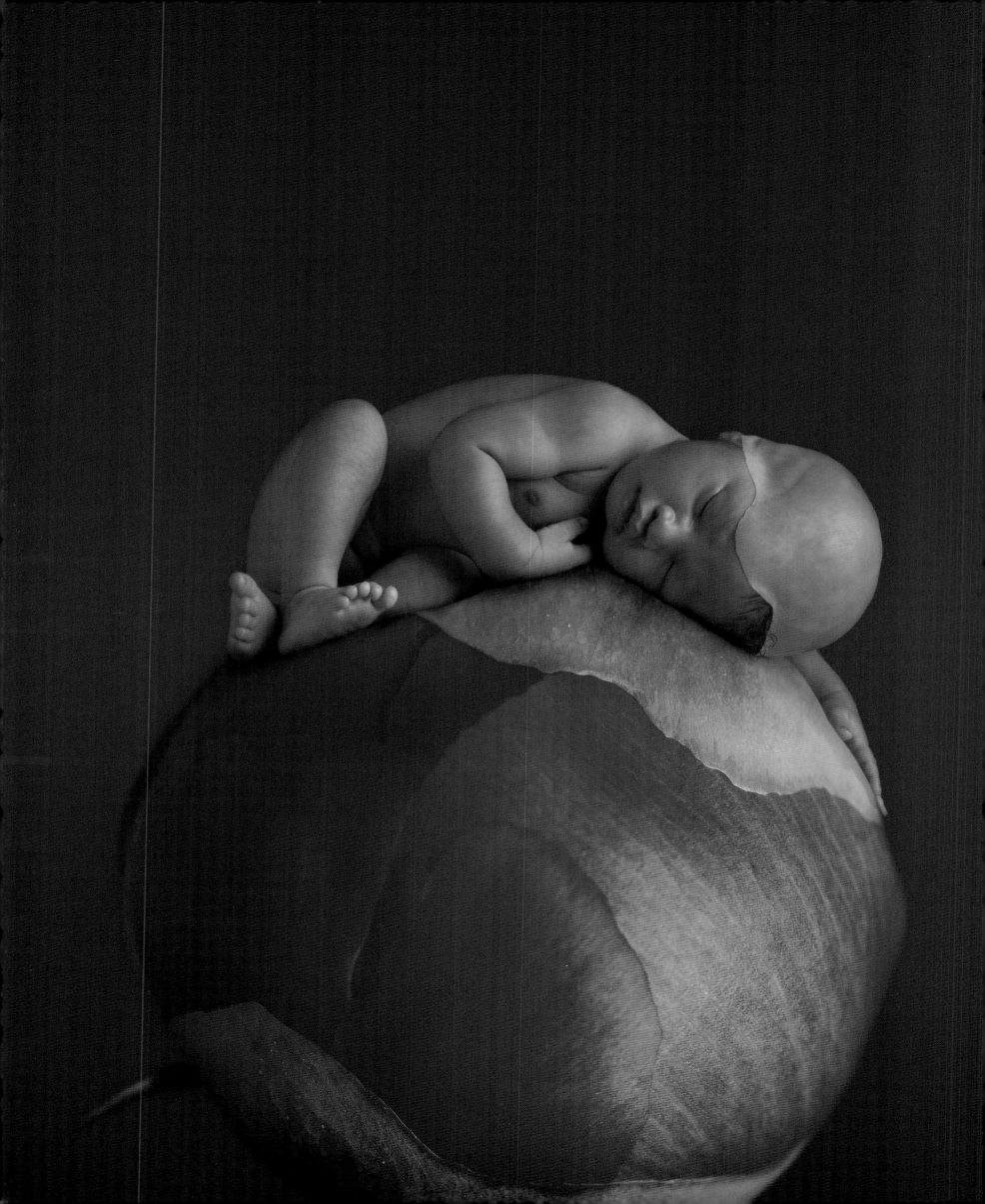

to keep you safe and warm

sleepy so head

your carriage waits to take you off to bed

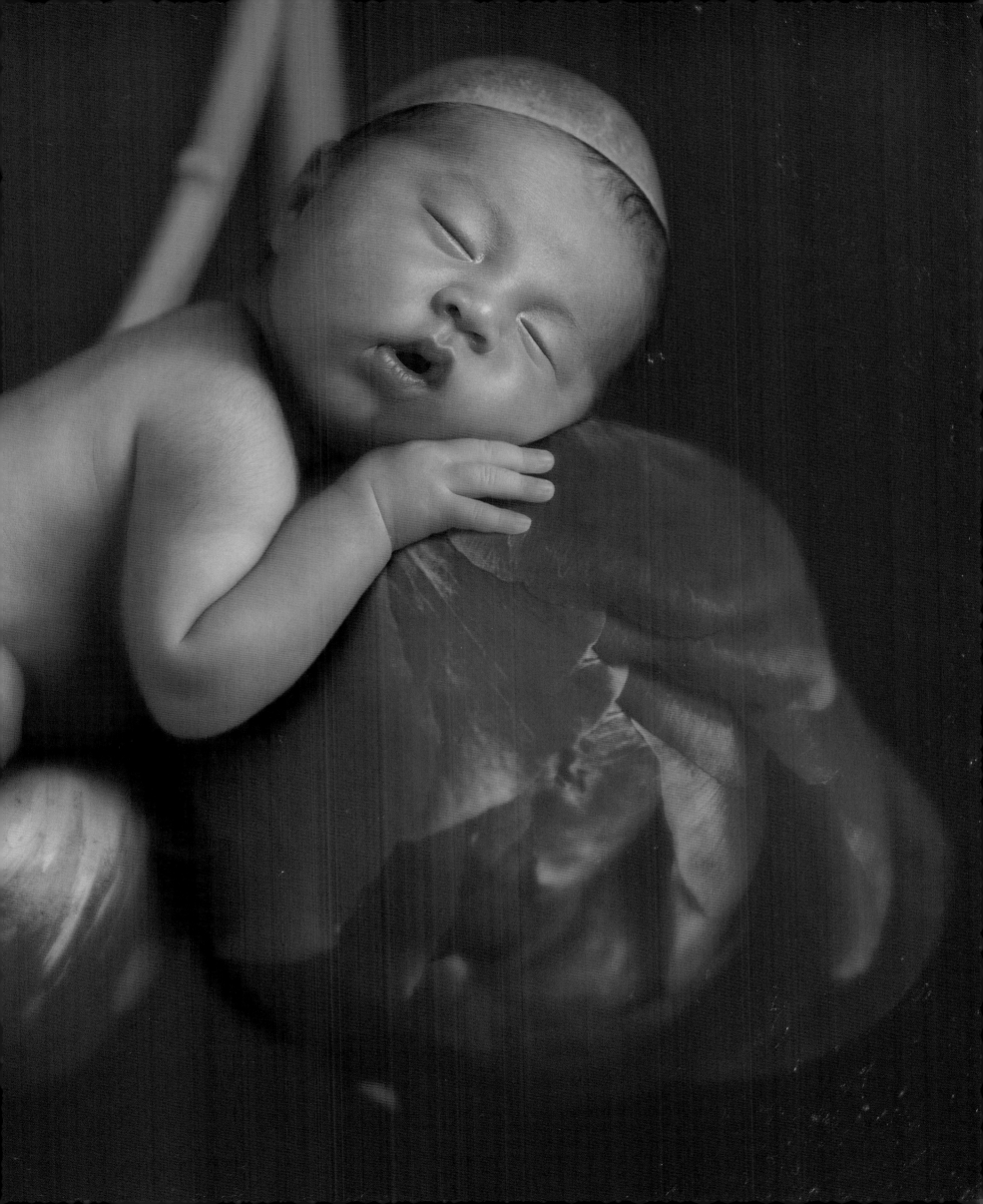

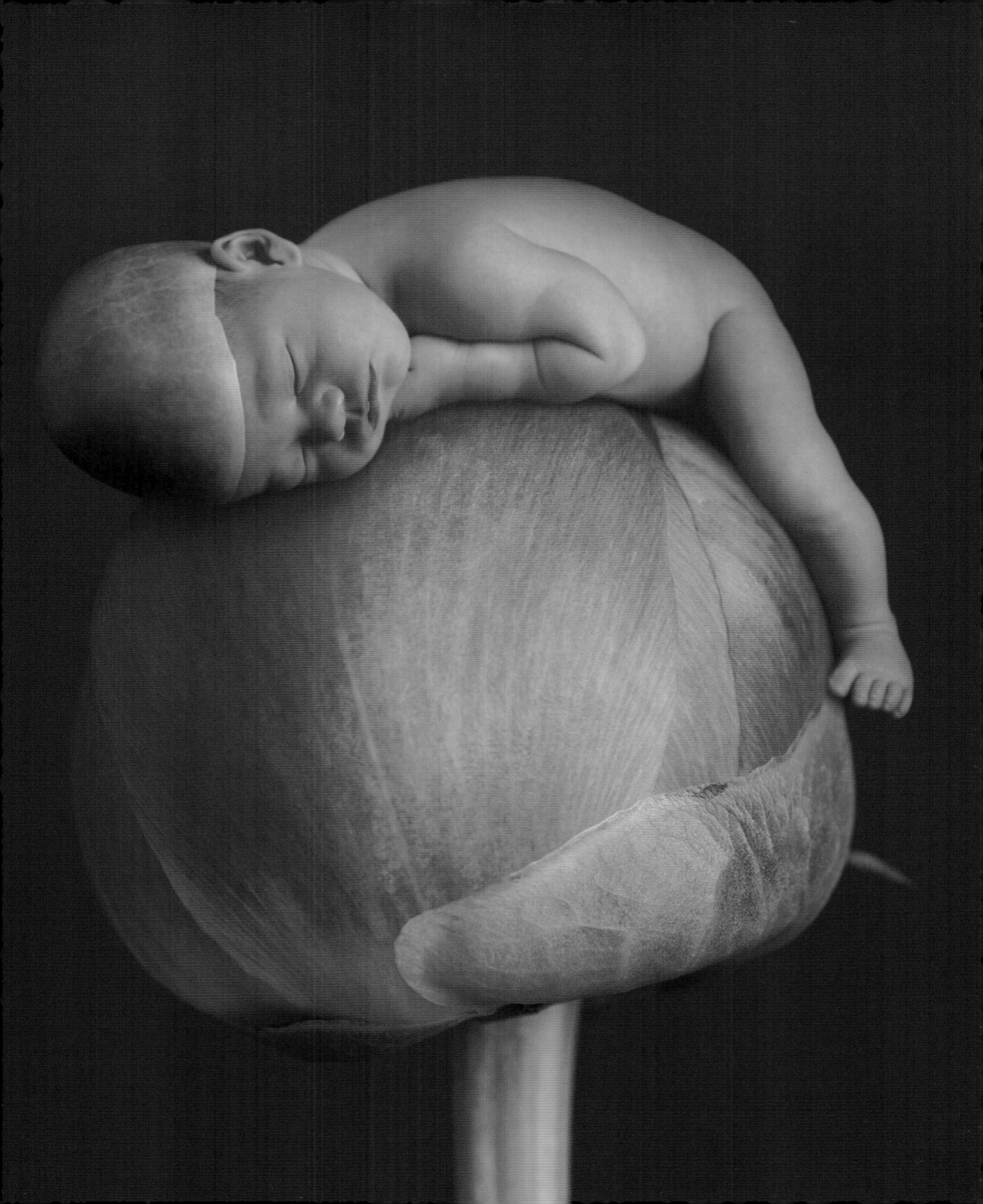

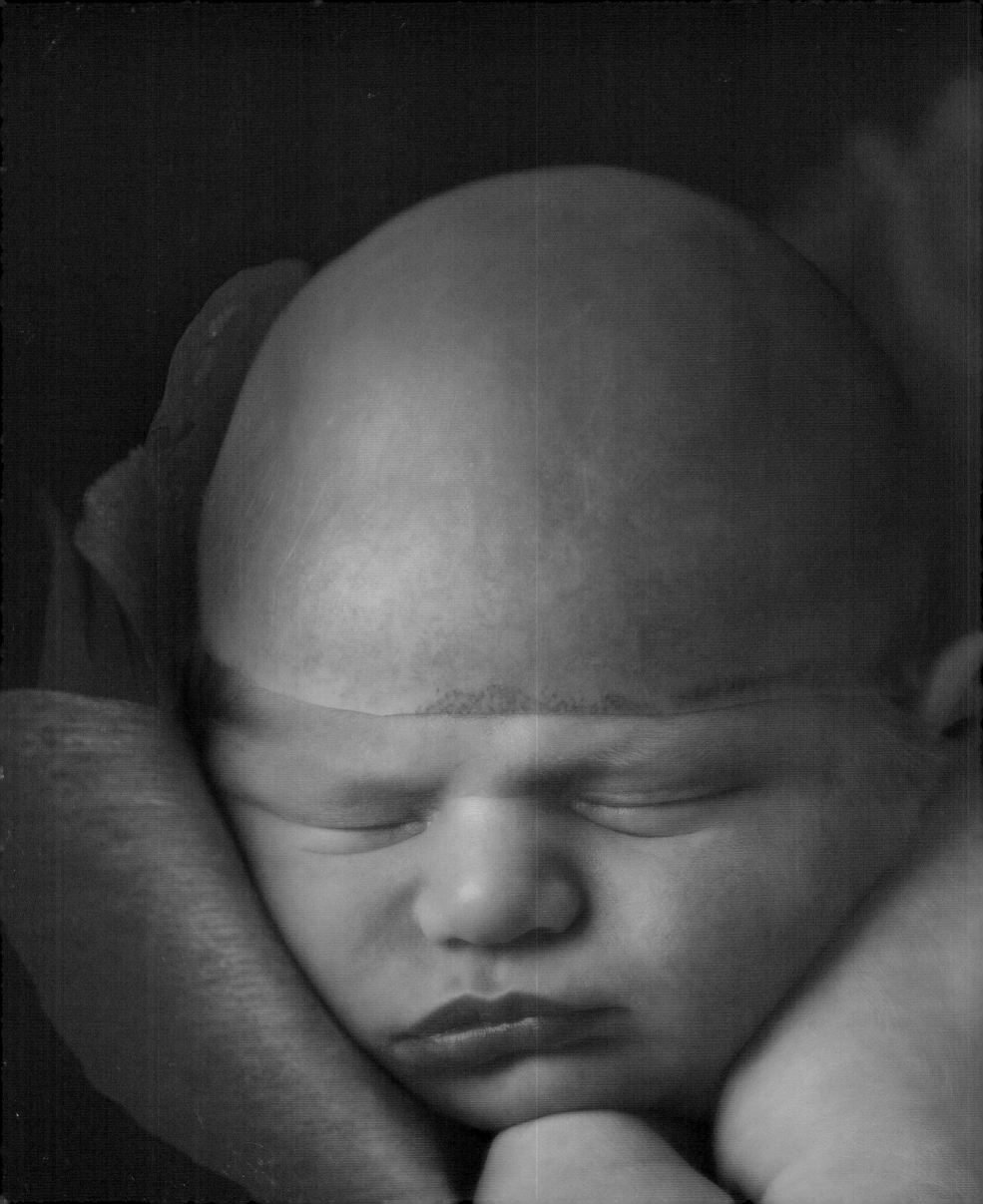